For Aurelia, Kim, our Ancestors, and Me.

HOW TO DRAW

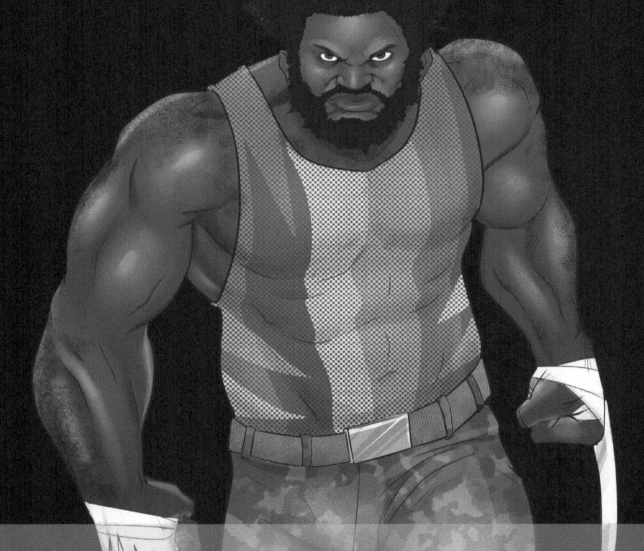

BLACK PEOPLE

By Ali Shabazz

CONTENTS

INTRODUCTION

Picture in your mind's eye a very daring person. This person loves to sing country music but can't get any gigs. Let's say this person is an art student, with goals of stardom. Their job makes money and they like where they live. They keep things simple. This person is outwardly kind but keeps people at a distance. They have a charming face but a wildness in their eyes. This person is a bit bohemian but also very principled.

Take a minute and visualize what this character looks like.

- How old is the character?
- What is their gender?
- What color is their hair?
- What colors do they like to wear?
- What is their build?
- Height and weight?

Can you see the character in your mind?

Good.

Now, what race are they?

Whatever race you chose, imagine the character is now black.

What changed about the character you were envisioning?

If your answer to the last question was "nothing," you couldn't be more wrong. Well, I mean in your head you are right but, there is a world of difference between the everyday experience of a Black person and a non-Black person.

That world of difference can be summed up in one term: **culture**. It's something I will reference heavily in this book.

My aim is two-fold:

> Establish a cultural approach to designing Black characters.

> Supply the techniques to execute on culturally driven character designs.

To show a cultural approach to character designs I define art as a language and character designs as a form of narrative.

It's like the old saying goes

"WRITE WHAT YOU KNOW"

and culturally focused designs rely on the experiences of the people your characters are designed after.

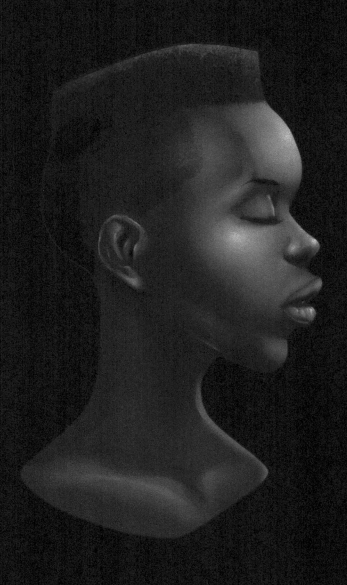

will walk you through my design process and how I narrow my focus down to the culture of a character; a method I call CAT *(Culture, Aesthetic, and Theme).*

As a juxtaposition to harnessing culture, I've also outlined some common tropes to avoid when designing a character.

After I've put culture on your radar, you'll be ready to move from the conceptual side into the technical side of this book.

"How to draw Black people" is meant to be an interactive learning experience. I have compiled a cache of files to be used in conjunction with this book. You will be prompted to access the supplemental file cache that can be downloaded at:

www.malik-shabazz.com/how-to-draw-black-people-page

If you do not have access to the internet, I have included some of the contents from the cache in an appendix at the end of this book.

I work in Clip Studio paint, so the tutorials work best in that program. If the program you are working with has limited features relating to lay-

you will have to find a way to work around those limitations.

This book is not designed for beginners.

But don't let that stop you. With the help of the internet most of what

I'm explaining can be googled if you need assistance. I may use several words that are new to you. In the back of this book there is a glossary that defines these terms. Words that can be found in the glossary are denoted by **bold** lettering.

Do not take anything in this book as gospel.

The world is changing, and new information is introduced almost daily. My understanding of certain things has changed over the course of the year it took me to write this book. I suspect in that same time things will change again. Keep an open mind as you read and never stop asking questions.

At the back of this book is also an appendix that will list sources of information for you to study outside of art itself. Keywords for google images searches, links to articles and videos and any important info that will help enrich you as a person as well as an artist.

This book also includes sections called "**hot takes**" which are tutorials done by other artists. Think of them as second opinions on what I cover. Sometimes, these tutorials will disagree with the core of the book; other times, the tutorials support the ideas.

This book was never intended to be the end all discussion for drawing Black people, but the catalyst for learning and growth. It is up to you, the reader, to take what you can use and discard what you cannot.

How to Draw Black People

FIGURE 1

SAY IT WIT'
YA *CHEST!!*

FIGURE 2

CHAPTER ONE: DEFINING ART AS, A LANGUAGE AND CHARACTER DESIGN AS A, NARRATIVE.

When you hear "Black people" what comes to mind?

Whatever your answer is, I can assure you it is different from mine. Language can be tricky that way. Though we can all agree on certain definitions, those very definitions can change, depending on the context.

Art can be just as tricky. When you first saw the character design to the left (Fig.1), what kind of impression did you get?

I was going for brave.

If that's what you got, great; if not, that's okay too. This was just an example of the similarities between written/spoken language and visual language.

A single word in any language is different from a single image. A character design is a purposeful combination of many different elements that, if done correctly, tell a story.

In this chapter I will discuss my philosophy on character design, introduce my cultural character prompt. By chapter 2 you will have the tools necessary to begin visualizing black culture in your designs.

My philosophy is simple:

"Art is a language, and character designs are stories told in that language"

Think of your art as your own personal language. The art that you create is an expression of your perspective and shared way of life.

How you feel about love, pain, joy and sorrow finds its way into the art that you make.

The same can be said about the way the mail man makes you feel, or your best friend, or a past lover. The impressions people make on you, either through personal experience or observation, serves as reference material.

When it's time to create a character, you recall the vibes you got from people and you personify them in your designs.

When you design a young, attractive character, you are telling the story of a person who gave you that impression.

When your design is presented to an audience, success is determined by the impression it makes.
A good impression would be a character that tells a story just by looking at it. The design reminds the audience of someone they know, or it shows them something they've never seen before.

A bad impression would be a character that gives no impression at all, or worse, gives an impression that was not intended.

FIGURE 3

As simple as my philosophy may be, it does create an issue:

If character designs are stories based on personal observations and past experiences, how does an artist design a character from a culture they have no experience with?

The more you learn about culture, specifically Black culture, the better you will be able to create characters that resonate with Black audiences. Although, creating authentic Black characters is not a simple undertaking, especially if you are unfamiliar with Black culture.

There are glaring inconsistencies between the shared observations of Black culture and the shared lived experience of Black people.

The results of these inconsistencies give way to racial stereotypes and offensive tropes.

FIGURE 4 "BLACK BRUTE" STEREOTYPE

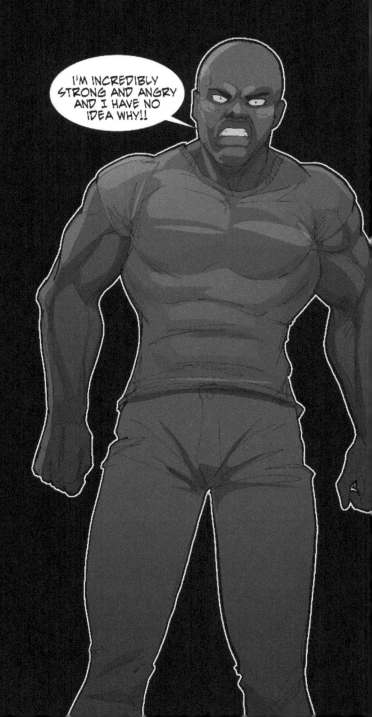

I'M INCREDIBLY STRONG AND ANGRY AND I HAVE NO IDEA WHY!!

How to Draw Black People

The more inexperienced an artist is with black culture, the more likely they are to cross a boundary they did not know existed.

Observation and imitation will only get you so far. The best bet is to rely on the ability of Black people and artists. Art is your personal language but when you design Black characters with culture in mind you are telling the story of a Black person. The only way that story can be authentic is if Black people are involved.

FIGURE 5

CULTURAL CHARACTER PROMPT

FIGURE 6-A

Character prompts are the bridge between an intended impression and its visual execution. If a character design is a story, a character prompt is the outline. To approach character design culturally there are 12 things you must set up about your character before you begin.

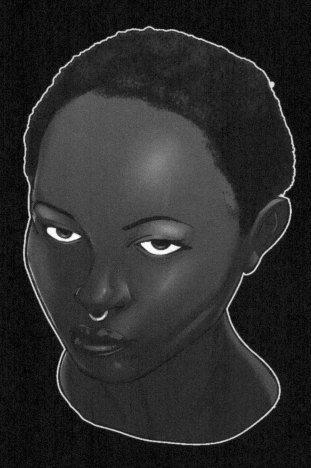

1. What is the character's **gender**?
2. What is the character's **race**?
3. What is the character's **sexuality**?
4. How old is the character?
5. Does this character belong to the dominant or oppressed culture within their world?
6. How does the world view your character's culture?
7. How does this character feel about their place in the world?
8. Does this character have any physiological or mental differences from most of the world?
9. What is the character's view on spirituality?
10. What is this character's expertise?
11. Where is the character from?
12. What is the character's value?

Not every character is going to be deep and well thought out. So, I've broken these questions up into four groups (Fig. 6-b):

- Background cast (questions 1-3)
- Recurring cast (questions 1-6)
- Supporting cast (questions 1-9)
- Main cast (questions 1-12)

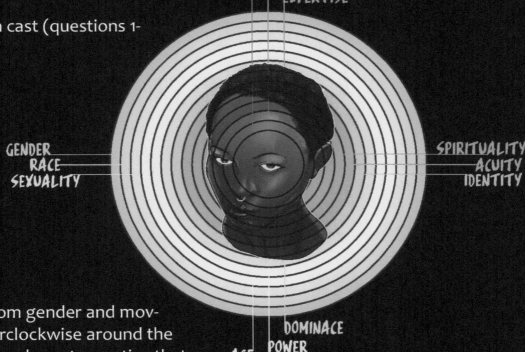

Starting from gender and moving counterclockwise around the layers of the character, notice that each answer to one of the twelve questions from the cultural prompt gives the design more depth. The design becomes a representation rather than a cliché.

FIGURE 6-B CLOCKWISE FROM TOP: MAIN CAST; SUPPORTING CAST; RECURRING CAST; BACKGROUND CAST.

"Value, Locality and Expertise"

Visually many of the terms I use may not be all that helpful. I will explain my terminology in detail during Chapter 3 "Culture, Aesthetic and Theme."

For now. I'd like you to use the cultural character prompt (the questionnaire from page 10) and come up with your own set of answers. Use your answers to craft a character with black culture in mind. Get feedback from Black artists and Black people. Make sure the impression you're building isn't an offensive one and resonates culturally.

If your answers remind a Black person of another Black person they know, you're on the right track.

FIGURE 7

How to Draw Black People

ACTIVITY #1:

Using the cultural character prompt as a guide design three characters:

- A woman
- A man
- A non-binary person

Design one char-acter to be the protagonist.

Another to be supporting cast.

And make the last character a re-curring cast member.

Design these characters to exist within the same narrative and set-ting

Refer to figure 6B (pg.11) to be sure that the correct number of ques-tions are answered for the corre-sponding character classification.

ex: Supporting cast members re-quire answers to questions 1-6 from the cultural character prompt.

Keep these designs handy, they are needed for activity #2.

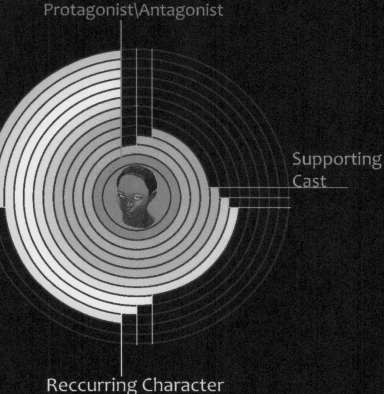

Protagonist\Antagonist

Background Character

Supporting Cast

Reccurring Character

FIGURE 8

CHAPTER TWO: DISMANTLING STEREOTYPES

History is overflowing with racist stereotypes and clichés, many of which are still in use. Few ever stop to ask why the Black masculine characters are often designed to be beasts of burden or why Black femme designs are typically sexually provocative. Unlike typical tropes that categorize a repeating motif, or theme, black stereotypes have been used to shape the perception of Black people. To avoid unintended offenses or contributions to offensive themes, let's examine these tropes and their origins.

FIGURE 9 LEFT TO RIGHT: THE STRONG BLACK WOMAN AND BLACK BRUTE. CLICHED TROPES TO AVOID.

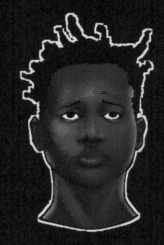

One of the first visual stereotypes to come into common use was the docile negro. Also known as a "pick-aninny" or "sambo"; this cliché told the story of Black people that were akin to mischievous children. By infantizing Black people, the stereotype contributed to acceptance of Jim Crow laws.

DOCILE NEGRO

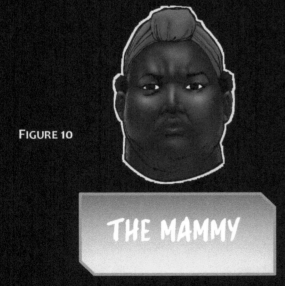

FIGURE 10

The Mammy came into prominence after the success of movies like "Gone with the Wind". While not a stereotype at the time, it quickly became one of the shallow interpretations of black women.

THE MAMMY

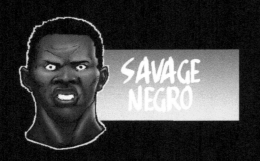

The savage negro was the first stereotype to take hold that depicted Black people as dangerous. Unlike the docile negro, the savage negro took advantage of the "kindness" of white people and betrayed them with violence.

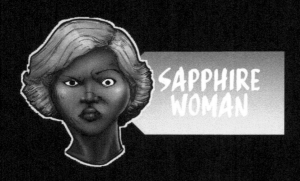

Around the same time as the Savage negro was taking hold so too was the visual representation of a dangerous black woman. Called "sapphire woman" the intended impression was that a woman that would lie, cheat and steal to get what she wanted.

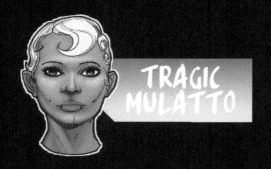

The tragic mulatto started in literature and in abolitionist publications. It's resurgence into pop culture came in tandem with colorism. Originally intended to elicit sympathy, its visual interpretation was reduced to a plot device.

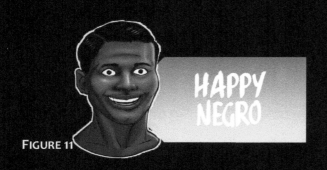

FIGURE 11

As black face became more unacceptable the image of the happy negro came to fill the void. All way smiling, always dancing, always singing, always happy.

An alternating impression of either exploitation or threat moves like a rhythm thru these stereotypes as they evolve. Notice also that the stereotypes become thinner, lighter in skin tone and more racially ambigu-

groundwork for the four most common racial stereotypes used for Black characters, presently. Unlike racist clichés of the past that openly dehumanized Black people, the following tropes are much more sub-

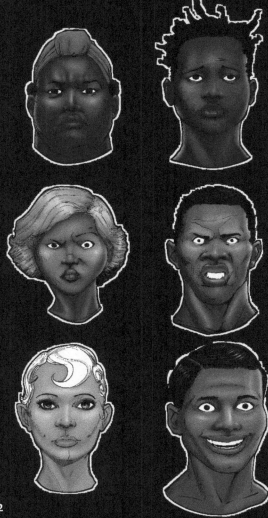

FIGURE 12

ous. The impact of these stereotypes far out strips their intended purpose. The Docile negro, the mammy, the savage negro, the sapphire woman, the tragic mulatto and the happy negro laid the

tle. By tracing the new back to the old, a new perspective can be gained on design choices for Black characters.

THE BLACK BRUTE

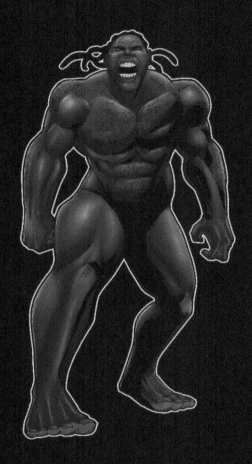

FIGURE 13

- Lowered brow.
- Angry expression.
- Can be any hue, but most notably dark skinned.
- Dark and bold color palettes sometimes both.

The black brute is an evolution of the docile and savage negro. Marked by a design that accentuates physicality and size (sleeveless shirts, thick, heavy looking accessories/weapons markedly bigger than most other characters). Originally the black brute was used in ways that likened black men to animals or lesser evolved humans. Now, this stereotype is a staple in the action and adventure genre, but it has several offshoots derived from the original.

Examples: Cyborg (teen titans) Luke Cage (Luke Cage), Barret Wallace (Final Fantasy 7) Augustus Cole (Gears of War) A (Naruto)

visual cues include but not limited to:

- Close cut fades or bald head. Cornrows and dreads are also common.
- Massive physique.
- Sunglasses.
- Athletic attire even when it isn't necessary.

STRONG BLACK WOMAN

- Leather clad or costumed sensually.
- Mostly dark skinned to mid tone.
- Generally, uses a sensual color palette with black integrated somehow.

Like the Black brute, the strong Black woman has evolved from a crude caricature into a common cliché. Where the brute is designed to be aggressive and physically strong, the strong black woman is sexually and psychologically aggressive. The cliché often serves as an opposite to shrewd feminine gender norms.

Example: Misty Knight (Marvel Comics) Lizzie Garland (Phantom) Foxxy Love (Drawn together)

FIGURE 14

Visual cues include:
- Large afro or 3c curly hair.
- Curvy figure, wide hips and bust.
- Form fitting attire that covers the entire body save for cleavage.
- Can have an angry or exaggerated/defiant expression.
- High heels.
- Often fitted with a large weapon if the setting is action oriented.

SAFE NEGRO

Visual cues include:
- Mid to light skin tones,
- Racial ambiguity.
- costumed indistinguishably.
- Jovial in expression and demeanor
- Neutral/ low saturation and value motif.

The safe negro cliché is an evolved form of the docile negro and the happy negro. Supportive, inviting, sociable, and understanding but v ually. The intended impression of this character is to fight one stere type, but instead it feeds into respectability politics and the existence of the "model Black person."

Examples: Liam Kosta (Mass Effec Andromeda) Monique (Kim Possible) Tom Dubois (Boondocks)

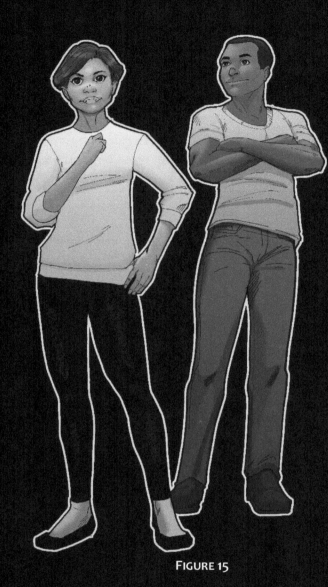

FIGURE 15

THUGS

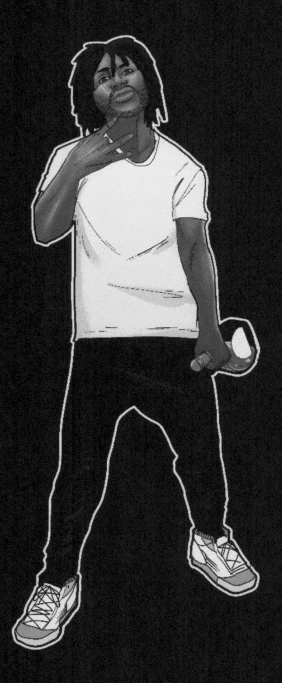

Visual cues include:

- blank shirts, baggy pants, hoodies.
- Muted or sharp contrast color scheme
- Bandanas, ball caps, durags and braided hair.
- Aloof yet banal demeanor, often obnoxious.
- Muscular and tattooed, can be overtly sexualized or asexual.
- Accessories related to drugs, alcohol, weapons and extravagance.

Thug is a new trope though it's a direct descendent of the savage negro. The wide eyed and unstable savage was a beast that radiated violent potential. The thug however is caricature of an everyday person living in the hood; so, the threat is instead exotic and conceptual. The thuggish Black character is the antithesis of the safe negro. It is the model of a "bad" Black person

Example: Franklin Clinton (GTA) Killer B (Naruto) Thugnificent (Boondocks)

FIGURE 16

DANGEROUS VS EXPLOITABLE

The common thread between racial stereotypes is that they imply Black people are: Dangerous, Exploitable, or Both.

defined by physical strength and/or stature (fig. 12). Lastly, there are racial stereotypes that visually imply both danger and exploitation, through juxtaposition (fig. 13).

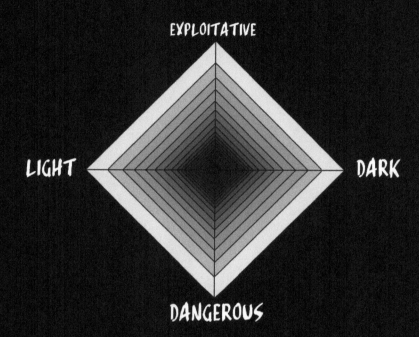

FIGURE 17 RACIAL BLACK STEREOTYPE SPECTRUM. THE FURTHER A DESIGN IS TO AN EXTREME THE SHALLOWER IT BECOMES.

Dangerous can be visually defined with size, physical build, facial expression, posture, extreme contrast colors and or sharp/jagged shape language (fig. 17).

On the other hand, **exploitative** character designs are visually defined by a single quality or ability. For example: The black brute is

There is also a **colorism** component to racial stereotypes modeled after Black people. Light and Darkness are relative to the design mold a character exists in. However, the darkness of a Black character's skin tone can vary depending on its moral alignment and proximity to the main characters.

For example: Black characters that are evil are often designed with dark skin tones. while sidekicks and allies to the hero of a story are designed with lighter skin tones.

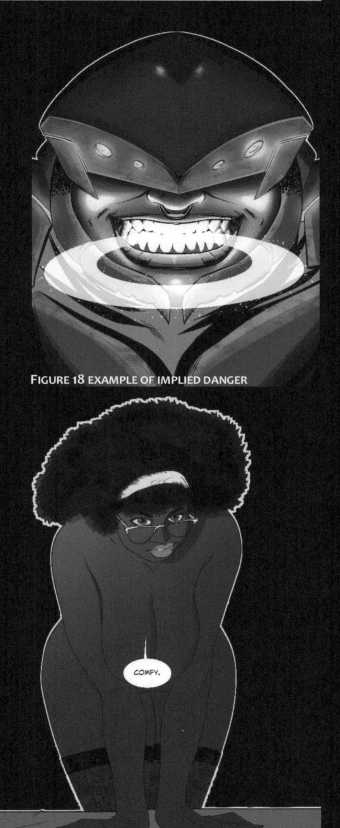

FIGURE 18 EXAMPLE OF IMPLIED DANGER

COMFY.

FIGURE 19 EXAMPLE OF IMPLIED SEXUAL EXPLOITATION

"JUST BECAUSE SOMETHING WORKS, THAT DOESN'T MEAN IT CANNOT BE IMPROVED."

The context surrounding a character design determines its offensiveness. Without context, however, a Black character design is more likely to be judged as a perspective on Black culture.

Taken to a logical extreme, the only way to avoid a racial stereotype about Black people is to avoid creating Black characters. Yet, a more nuanced point of view and a practical approach toward design choices can easily solve most problems before they arise.

Here's a list of things you can do to avoid racial stereotypes:

1. **Read up on colorism:** As a societal problem, colorism is a topic of discussion in black culture. However, amongst visual artists colorism is broached by the socially conscious only. Black characters are not plentiful and yet most of the ones that do exist are much lighter in skin tone than many black people. Being mindful of the issue, visual artists can sidestep unintended offenses by avoiding proven racist tropes.

2. **Invest in innovative ideas:** Most of these stereotypes have been around for decades and while they have evolved, they are still based on the same core concepts of exploitation and danger. If you rely on established archetypes when designing Black characters, you increase your chances of offending Black audiences.

3. **Get feedback from Black people:** Nothing can substitute the lived experience and perspectives of Black people. Reach out to your Black friends and colleagues and get as many eyes on your design as possible.

4. **consider *character contrast*.** A Black character will stand out in a group of non-Black characters (Fig. 19). If, however, you add another Black character, one that can serve as a contrast for the other, you create variety.

FIGURE 20

"DIVERSITY IS A QUOTA. REPRESENTATION IS AN INVITATION."

A stereotype is not a terrible thing, they are just exaggerations and generalizations. Racial stereotypes function like any other trope, except they imply behaviors and attributes to be intrinsic. Visual narrative is a major thoroughfare for racial stereotypes. Many of the tropes that character designers lean on when creating Black characters have roots in racial stigma and political scapegoating. Avoiding racial stereotypes isn't difficult, it just requires a bit more effort. Just follow this one simple rule:

"If you've seen it before, do something else."

If your design resembles any Black character you can think of, start over. There's a good chance you've incorporated some racial trope you are unaware of. Moreover, Black people are diverse within our own culture. The clichés have never accurately described or stood for any majority of Black people across the African diaspora. That isn't to say All Black characters are offensive. Despite the history, Black audiences

have come to love characters that draw directly from stereotypes. But the acceptance of mischaracterizations should not be taken as acceptance of the motives and disrespect behind them. It's imperative to know the difference between what is rooted in hurtful history, what is of cultural significance, and where the two overlap.

By observing Black culture, aesthetics, and what they imply thematically to a design, the distinction between exploitation and representation is made clear.

Something I call
"Culture Aesthetic and Theme"

FIGURE 21

How to Draw Black People

ACTIVITY #2

In the first activity I asked you to answer questions from the cultural prompt found on page 10 and create three designs from the answers.

For this exercise, compare your designs to the stereotypes examined in chapter 2. Did your designs resemble any of the tropes outlined?

Redesign your characters from activity #1 with racial stereotypes in mind. Think outside the boxes populated by popular characters from well-known franchises. Hold on to these designs as well; they are needed for the next activity.

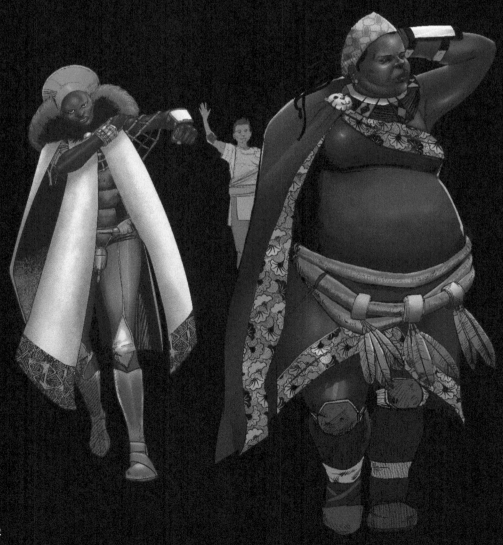

FIGURE 22

CHAPTER THREE:
Culture, Aesthetic and Theme

FIGURE 23

The foundation for the cultural character prompt from page 10 is based on three concepts:

Culture

Aesthetic

Theme
(CAT for short)

In this chapter I will explain each concept and how to apply them to designing Black characters.

Culture, aesthetics and theme play deeply into the look of a character design. First let's look at culture. Chapter one defined art as a language. Chapter two examined the negative connotations that occur when designing Black characters.

The last step to translating observed culture into visual language is to de-

more opportunity to add cultural identifiers modeled after the cultural production of Black people across the African diaspora. Cultural identifiers are the subject of Aesthetics in CAT. Theme, the last letter in the CAT acronym, refers to the purpose of the character or the vice or virtue it stands for.

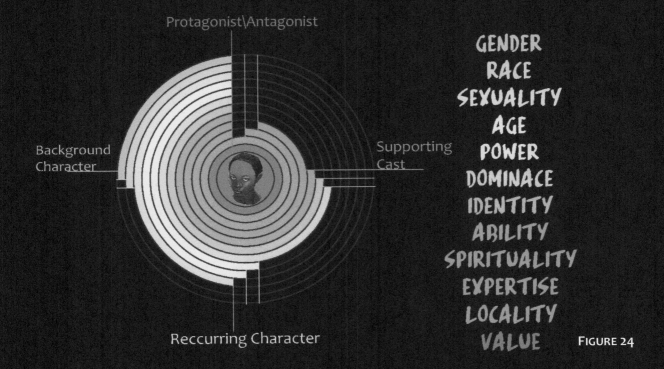

GENDER
RACE
SEXUALITY
AGE
POWER
DOMINACE
IDENTITY
ABILITY
SPIRITUALITY
EXPERTISE
LOCALITY
VALUE FIGURE 24

fine the 12 levels of depth to cultural character design (fig. 23). Each level requires more understanding of the character and their place within the narrative or setting. The levels themselves are what make up the concept of culture in CAT. The deeper a character design is the

Cultural production is art made by and/or representations of a defined group of people. Things like music, poetry, dance, food, clothing and literature are all forms of cultural production. The African diaspora spans the globe, so the cultural production of Black people is remarkably diverse and robust. Cultural identifiers are the focal point of building a design with cultural significance. The groupings of the 12 levels (fig 23.) apply best to a cast or group of characters. For the creation of individual characters, it is best to think of the 12 levels as attributes on a scale of specificity. Here are my answers to the cultural character prompt, along with brief explanations on the visual information I derive from them.

1.WHAT IS THE CHARACTER'S GENDER?

First things first: **a design is not a person, it's the impression of a person.** People have genders, designs have **identifiers**. Gender identifiers convey that a design is an illusion based on the gender of actual people. For this question I decided: Femme presenting, agender.

2.WHAT IS THE CHARACTER'S RACE?

Same as with gender, a character design has no race instead it has **phenotype** identifiers.

This book is about drawing Black people so I've decided that this character will be am impression of a Black person.

FIGURE 25

3.WHAT IS THE CHARACTER'S SEXUALITY?

Depending on the story a character's sexuality may be on full display, casually implied or purposefully hidden. Knowing the character's sexuality will determine its relationship to other characters.

I've decided to make this character queer, though I feel the sexuality of this character **visually insignificant**.

4.HOW OLD IS THE CHARACTER?

The exact age of a character isn't necessary for visualization. It is best to think of age in terms of phases.

Babyhood (0-3 years)
Adolescence (4-10)
Preteen/teen (11-15)
Young adult (16-25+)
Adult (25-45+)
Older adult (40-50+)
Elderly (60-??)

The look of a character needn't always match up with their actual age, either.

The character I am a designing will fall into the young adult category.

5.DOMINANT OR OPPRESSED?

Power structures in stories can be black and white or they can be something of a spectrum. Knowing where a character fits within the power structure of a story will define its gravitas. Where a character fits in translates thru posture, stature, color scheme and other aesthetic choices.

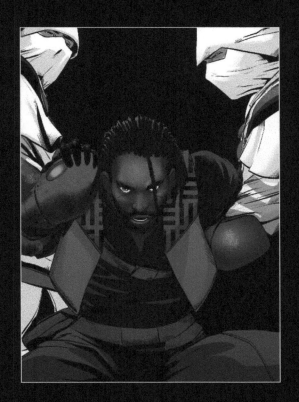

FIGURE 26

6. HOW DOES THE WORLD VIEW THE CHARACTER'S CULTURE?

"Your kind aren't welcome here"

The way characters react to one another informs the audience's impression of each character. The character's place in the social hierarchy will affect the way it looks, and how it carries itself.

There is an important distinction here: The way the audience views a character can be independent of the way characters are treated in a story.

A character may look like a villain, but to the audience that same character may be a hero.

From a design standpoint, the task is to give the audience visual evidence for why the world of the story views the character as intended.

Using the answers from the first five questions of the cultural character prompt, imagine the first impression the character gives off to other characters.

Try to conceptualize it with single descriptive words like:

Dangerous, Brooding, Mysterious, Unnerving, Unpredictable

FIGURE 27

7. WHAT IS THIS CHARACTER'S PLACE IN THE WORLD?

Questions 1-6 defines the impression of the character objectively; how the world views the character. This question defines how the character views the world. The juxtaposition of how the world perceives the character and how the character perceives the world reveals its identity.

For example, here is my answer:

- -Believes the world is bleak but confusing.
- -There are good people and bad people both are just trying to survive.
- -Better to not get involved in issues bigger than they understand.

Three perspectives are enough for me and I caution artists to be careful and not overdo it.

8. IS THIS CHARACTER DIFFERENT MENTALLY OR PHYSICALLY?

Consider the character's mental and physical health/differences. Things like blindness, autistic spectrum disorder, albinism, anxiety/depression, and paraplegia are all things that will help shape a design.

The character I'm designing suffers from social anxiety disorder.

FIGURE 28

FIGURE 29

10·WHAT IS THIS CHARACTER'S EXPERTISE?

An **"expertise"** is something the character is not only good at, but the best at. It is a quality that distinguishes the character. Expertise can be something practical like shooting lightning bolts from fingertips, or it can be something more nuanced like resiliency or perseverance. The more subtle the expertise the less it will be visual.

The lack of an expertise can also be one as well. If the cast of characters is filled with remarkable abilities and character traits, a character that has neither will naturally set itself apart.

Always keep the narrative and character contrast in mind.

9·WHAT IS THIS CHARACTER'S VIEW ON SPIRITUALITY?

Whether a character is a priest, heretic or something in between, there are visual cues that imply where the character stands. Tools for expressing spirituality can be prominent or subtle, however they are important. Spirituality, (not to be confused with religion), is a big part of culture; one that will resonate with Black audiences if done right.

11. WHERE IS THIS CHARACTER FROM?

Admittedly, this question does seem basic. Yet, from a cultural perspective this can mean everything.

Climate, food, music, art, style/fashion, these are all things that are derived from locality.

Choose a place or multiple places that resemble the world your character lives in. Build up a reference library and experiment with it.

FIGURE 30

Keep in mind all the answers you have so far when researching locales.

12. WHAT IS THIS CHARACTER'S VALUE?

The final addition to a character this deeply defined is to affix a value or moral to it.

Values like: Honesty, hope, confidence, trust, selflessness, humility, perseverance.

Leave the moral implications of right and wrong out of the equation. An honest Villain is just as compelling as selfless hero (if not more so).
Every artist will interpret values differently, that is where personal visual language comes into play. This last question is less about the design and more about the way the artists sees the world.

Take in all the answers and envision what the impression should look like.

Next, let's look at Aesthetics.

AESTHETICS

Culture provides a concept that is aesthetically defined through **visual cues**.

FIGURE 31

This is Erica "Fast Lane" James (fig.31). I created this design using the cultural character prompt. I went through each answer and decided what was important to bring the design together.

NON BINARY
BLACK
PANSEXUAL
YOUNG ADULT
OPPRESSED
STIGMATIZED
COMPETITIVE
SOCIAL ANXIETY
ATHIEST
RACING
WATTS/LONG BEACH
SACRIFICE

Visual cues convey Black culture to audiences. Hair styles, shoes, style of dress, tattoos, earrings, and accessories of all kinds give information to the viewer about the type of character they are seeing.

It isn't necessary to include every part of the prompt into a design; however, it is important to have a wealth of information to draw from.

The visual cues that make up the aesthetics of a character design are:

COLOR SCHEME

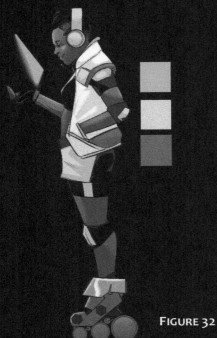

FIGURE 32

SHAPE LANGUAGE

FIGURE 34 SHAPE LANGUAGE OR "SILHOUETTES" IS AN UN-DERLYING CONCEPT OF CHARACTER DESIGN. IT IS THE THE-ORY THAT PEOPLE ASSOCIATE THE SHAPES THEY SEE WITH FEELINGS AND EXPERIENCES. ROUND SHAPES ELICIT FEELINGS OF COMFORT, SHARP SHAPES DANGER, FLAT OBJECTS STA-BILITY, ETC. SHAPE LANGUAGE APPLIES TO ALL FORMS OF VISUAL STORYTELLING.

POSTURE

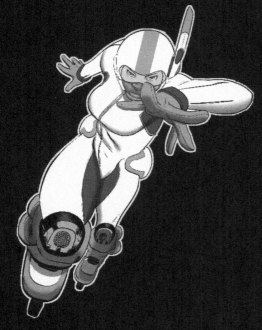

FIGURE 33

COSTUMING

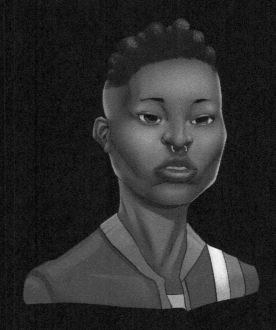

FIGURE 35

For the color scheme I wanted to focus on blue hues that stand for both purity and peace, something the character lacks but desires. The three hues I've chosen can be adjusted to mirror the character's mood as well.

When choosing a color motif for Black characters the choice of skin tone is important. Choosing a darker skin tone for a character meant to be mocked or evil play into colorism tropes that are offensive.

With Erica, I chose a medium tone because I didn't want there to be room for **racial ambiguity**.

For shape language I focused on round shapes and rounded edges. I wanted the character to appear both soft and sturdy, resilient but pure. In the style I'm using posture is more important than shape, but it still counts for a lot.

The pose of a character is vital and works in tandem with shape language. Poses can be iconic, or they can tell the audience things about a character that colors, and shapes cannot. For Erica I emulated the wide sweeping motions of professional skaters.

Costuming is often the most fun part of character design. The look of a character is also important to convey its culture. The setting I envision for Erica is a futuristic one but also dystopic.

If you are unfamiliar with shape language, color scheme, posture and shape language, now would be an appropriate time to learn. This book's focus is on Black people and our culture. However, there are several resources, online and in bookstores, that focus broadly on character design.

If you are familiar with the four concepts I outlined, think on how you can actively use then in your own design process. Apply what you know and what you've learned about crafting characters with culture in mind.

FIGURE 36B

THEME

Last of the CAT acronym is theme. In relation to culture and aesthetics, theme is the purpose of the design. Remembering that art is a visual language, theme corresponds to the subject matter of a statement. A character can be blunt and crass in design, yet also subtle in expression. That's just a fancy way of saying it is gritty or lighthearted and chaste, the theme of a character design will tailor the audience's expectations.

Finally, what the character symbolizes, if anything at all, will present itself through its theme. The symbolism of character design exists both

FIGURE 37

up to the artist to decide how best to use the information and tools available to bring a character to life. Within the theme of a character the audience can learn what time period a character belongs to or what genre a story takes place in. Style is also something conveyed through theme. If a story is dark and within the world of the story and outside of it. When a character's culture is written (by using a prompt like the one found on page 10) its value and place inside the illusory world of the story is carved out. With theme the task is to decide what the character reflects from the real world. Values, morals,

ideologies, the fabric of culture; theme answers the question of worth to audience members directly.

From the research needed to answer the questions from the cultural character prompt, the ideologies and customs of Black people will become clear.

Reconciling the existence of a character within the world of its story with the experiences and ideals of human existence is the essence of theme.

FIGURE 38

ACTIVITY #3

FIGURE 39

How to Draw Black People

It's time to put what you've learned to work. Start a new cultural character prompt sheet. Research the answers to the questions, build a reference library based on the character prompt and make yourself aware of the cultural boundaries and significance of the kind of character you are creating.

Culture
Aesthetics
Theme

It's not a step by step process but a framework or philosophy on building characters.

Apply CAT to the best of your abilities and compare the second design to your first.

CHAPTER FOUR: ANATOMY
A BODY OF LANGUAGE

This section covers anatomy as it pertains to creative choices. What often omitted from art tutorials is an explanation of gender and sex. These are complex and sensitive topics, but gender and sex are necessary to discuss. I will simplify these topics to the best of my abilities; however, I strongly suggest that you research gender, sex and the differences between the two to get the most out of this part of the book.

FIGURE 40

LET'S TALK ABOUT SEX

The majority of human beings fall into two categories:

Female or Male

Yet at the same time, there are millions of people that don't fall into either category. **Intersex** is a classification for people born with a different combination of external and internal reproductive organs than most.

Sex is not binary and so gender, something that is commonly conflated with sex, cannot be **binary** either.

If you can accept that there are people who do not fit the definition of male or female, then that is a suitable place to start.

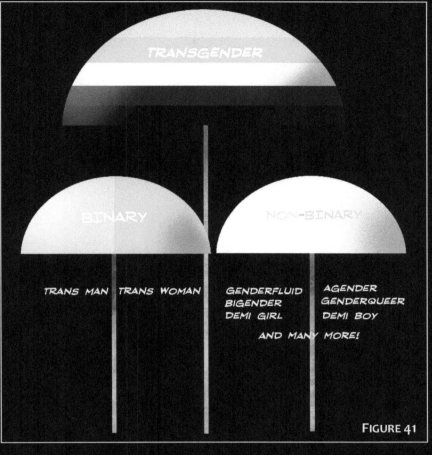

TRANS MAN TRANS WOMAN GENDERFLUID AGENDER
 BIGENDER GENDERQUEER
 DEMI GIRL DEMI BOY

 AND MANY MORE!

FIGURE 41

A character design is not a person, it has no gender or sex, inherently. Traditionally, artists rely on gender norms to convey gender. However, times have changed, and gender norms are quickly becoming obsolete. Because a character design isn't a person, using a binary perspective (Male/Female) makes little sense. Not only can a character's gender change multiple times during the design process, but there are multiple genders outside the norm (fig. 41).

A better way to think about gender regarding character design is to think of it as a spectrum:

Feminine Masculine

Androgynous

On one side of the spectrum there is feminine **gender presentation,** on the other end, masculine presentation, and in the middle, androgynous presentation. A designer must get in the shoes of the character and decide how it would present its gender if it were a real person. Working with a character prompt of some sort is tremendously helpful because it will give the best sense of the character's identity. Without a prompt, artists must rely on aesthetic choices and visual cues to communicate gender. But what are those visual cues that imply gender?

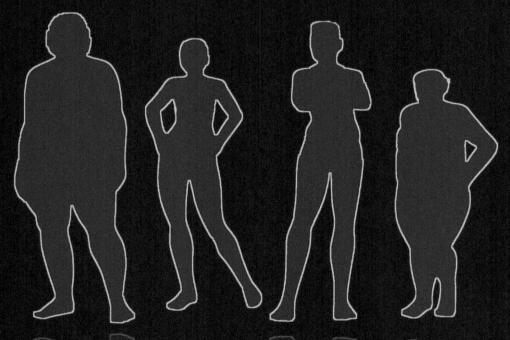

FIGURE 42

The truth is shape really cannot be relied upon to communicate gender or sex. Anatomical differences are common but not common enough to have two molds cover all humans.

The contrast between the shape of men and women is only a single part of what visually defines gender.

The color scheme of a character also hints at its gender. Gender norms have created an association between genders and colors. For example: pink onesies for girl babies and blue ones for boys. Another factor is the posture or stance of a character. Gender norms suggest female characters should display softness, sex appeal and grace; and male characters should display physical strength and stability.

The last visual concept of gender is costuming. The clothing of a character, or lack thereof, plays on what people expect a man or woman to be wearing.

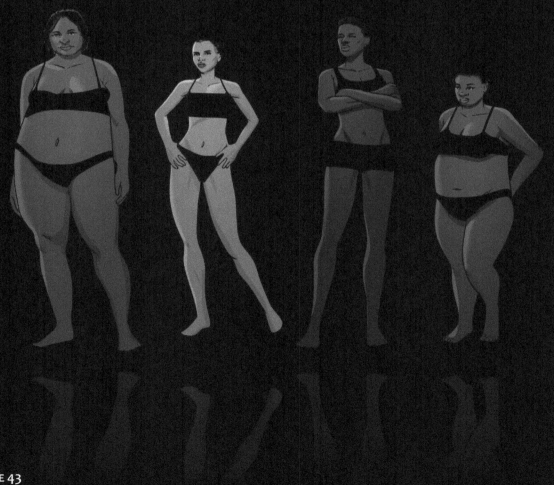

FIGURE 43

Color scheme
Posture
Shape language
Costuming

These four concepts are the basis for gender presentation. A character can be any gender, but the way an artist presents its gender determines how it will be perceived. If I wish to create a masculine man I think of color, posture, shape and clothing traditionally tied to masculinity. On the other hand, if I wanted to make a feminine presenting man, I consider the opposite. In either case I must decide how masculine or feminine I wish the character to present.

FIGURE 44 CONTRASTING MASC AND FEMME GENDER PRESENTATION. MASCULINE CHARACTER DESIGNS THAT ARE SHAPED RIGIDLY, THICK, WITH ERECT POSTURE, SUBTLE COLORS SCHEMES AND COSTUMED TO ACCENTUATE MUSCLE MASS AND UTILITY FEMININE CHARACTER DESIGNS THAT ARE SHAPED LITHELY, SOFT, WITH OPEN POSTURE AND COSTUMED TO ACCENTUATE SEX APPEAL

Visually, it's safe to assume that the characters in figure 44 are impressions of a woman and a man. Audiences have come to expect men and women to be depicted this way.

If gender is removed from the outset, then design focuses on visual language instead of gender norms. The association of gender and color become inconsequential. Costuming combines masculine and feminine qualities. Posture and shape language translate values and emotions.

Gender presentation allows gender to be designed outside of gender norms. What the audience expects can be used to surprise and innovate. A masculine character design can be any gender; same goes for feminine and androgynous designs.

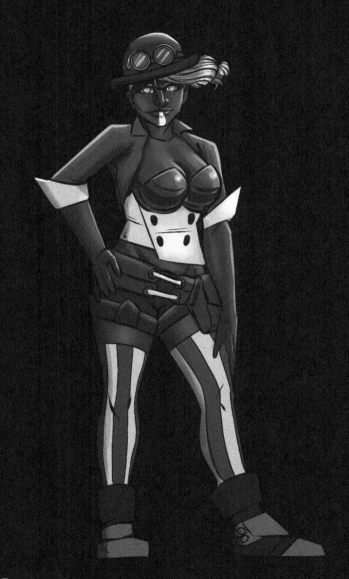

FIGURE 45

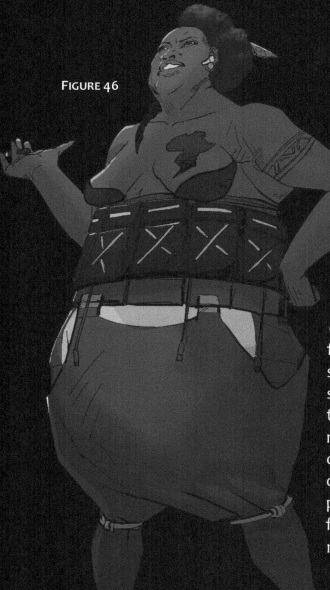

FIGURE 46

MASCULINE PRESENTATION is

based on practicality. Pouches, clasps, pockets, tools hanging from the apparel, subdued color palettes, bare chest and freedom of movement around the shoulders and arms. Masculine designs are tied to craft, vocation and trade. It is also more acceptable for masculine designs to be dirty, rough or disorganized, as these are signs of dedication to work. The more physical labor and capability can define a character design, the more masculine the design becomes.

FEMININE PRESENTATION is based on

displaying the body and coordinated accessories. Movement and form is more important than practicality. Clothing is cut to fit the body and color schemes are more fanciful. Pastels, vivid, sensual and vibrant colors are common. The shape language of feminine aesthetics accentuates the hips and bust of a character and softness is essential. Flowing fabrics that drape the body or move with the body is another common attribute. The accessories associated with this type of gender presentation are more about extravagance, expression of identity or opulence.

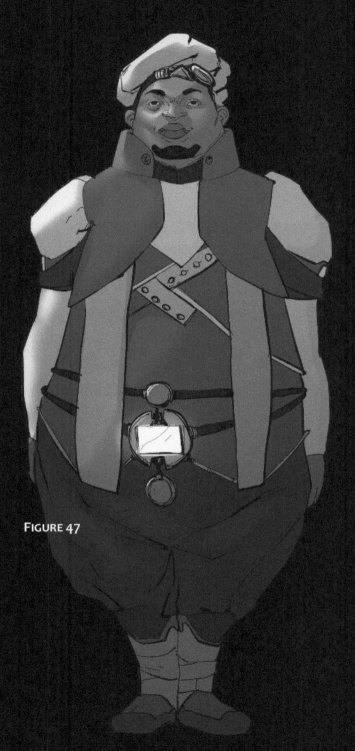

FIGURE 47

ANDROGYNOUS PRESENTATION is the balance or contrast of feminine and masculine characteristics. Equalizing the rough, utilitarian attributes of masculine presentation with the soft whimsical themes of the feminine requires subtlety and nuance; but it also requires the rejection of gender norms. Unlike the other two types of gender presentation androgyny isn't tied to a gender norm or any specific gender. There are no color schemes, shapes, poses or costume choices that are widely accepted and commonly used. The one recurrent theme of androgynous designs are that they leave room for doubt about the character's gender.

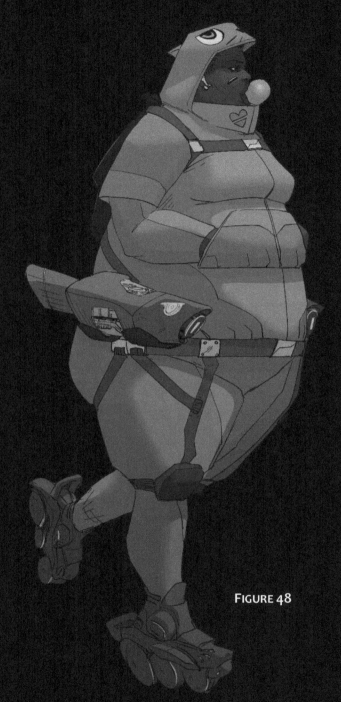

FIGURE 48

Gender presentation is an evolution of gender norms. It builds off established ideas about gender and applies them through visual communication equilaterally. The cultural character prompt helps define what a character's gender presentation might look like.

Gender should be approached with nuance and every character should represent a different interpretation of what it means to be masculine, feminine and everything in between.

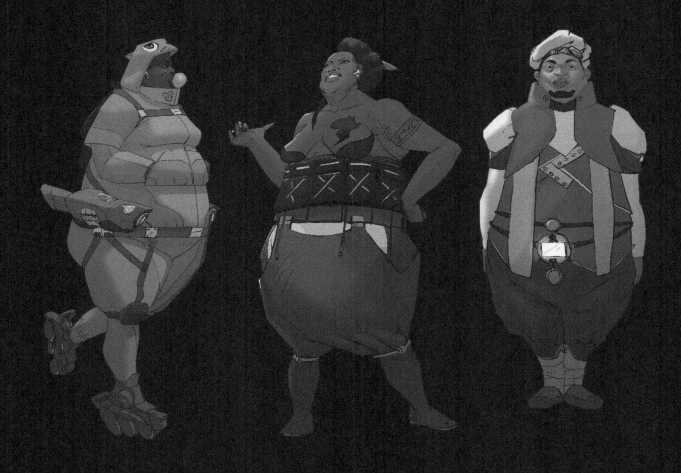

FIGURE 49

ACTIVITY #4

THE THING ABOUT SHAPES

Breasts don't make a woman any more than broad shoulders make a man, and for everyone not belonging to those genders, those ideas are completely useless. Relying on anatomy alone to define a character's gender narrows the options available for gender presentation and promotes gender norms.

In the supplemental file that comes with this book you will find sample shapes like the one in figure 50. Download these files and import them to your drawing software. While keeping the shape intact, Practice applying masculine, feminine and androgynous gender presentations to the sample shapes.

Create three designs one **feminine**, one **masculine** and one **androgynous**

FIGURE 50 FIGURES 46-48 WERE ALL CREATED USING THIS SHAPE

FIGURE 51 THE VASE SHAPE IS A CLASSIC FORM USED BY DISNEY AND OTHER ANIMATIONS STUDIOS FOR HEROINES AND FEMININE PRESENTATION. TRY TO RECREATE WHAT I'VE DONE HERE USING YOUR OWN INTERPRETATION OF MASCULINE, FEMININE AND ANDROGYNOUS GENDER PRESENTATION.

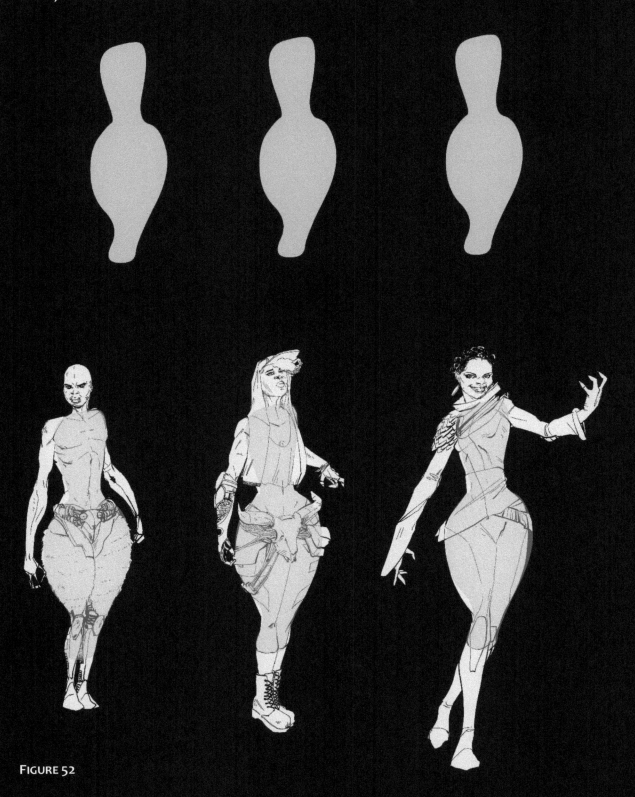

FIGURE 52

CHAPTER FIVE: FACIAL ANATOMY

There are five distinguishing features that all Black people share to varying degrees.

Those five features are what I call **African Phenotype Identifiers** (API).

This chapter covers API while offering my own techniques for drawing them.

FIGURE 53

How to Draw Black People

WHAT IS PHENOTYPE?

For the purpose of this book, phenotype is defined as *the physical attributes that indicate heritage belonging to a specific race of human beings*.

FIGURE 54

The African phenotype is unique because it is both exclusive and diverse. Across the African diaspora Black people look different from each other while looking different from everyone else.

There are five distinct physical features that all Black people share, I call those feature African phenotype identifiers or API for short.

The distinct features are:

-Nose
-Mouth
-Hair
-Skin tone
-Cheek bones

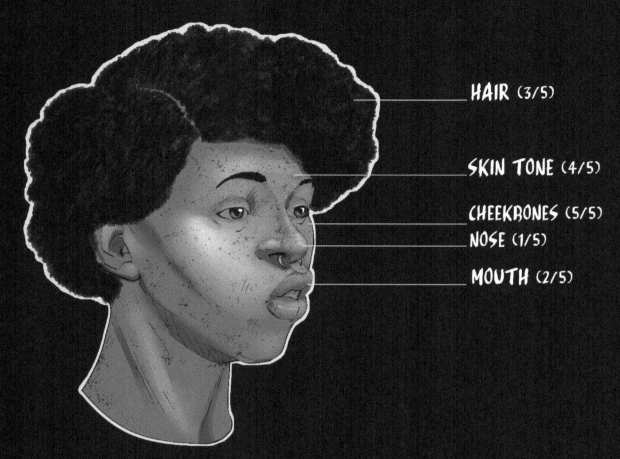

HAIR (3/5)

SKIN TONE (4/5)

CHEEKBONES (5/5)
NOSE (1/5)

MOUTH (2/5)

FIGURE 55 IN ORDER OF DISTINCTNESS THE 5 API ARE: NOSE, MOUTH, HAIR **(3C/4C)** SKIN TONE AND CHEEK BONES. **THIS CHARACTER HAS 3 OF THE 5 API NEEDED THE HAIR, THE MOUTH, AND THE CHEEKBONES ARE STRONG ENOUGH TO CONVEY THE RACE** OF THE CHARACTER.

Having one or two APIs makes a character look racially ambiguous enough to be considered of African descent. Although, the lack of APIs will leave room for doubt unless the race of the character is addressed directly.

To ensure that the race of a character design translates follow the rule of 3/5ths:

A character design with at least three of the five African phenotype Identifiers will present as Black.

How to Draw Black People

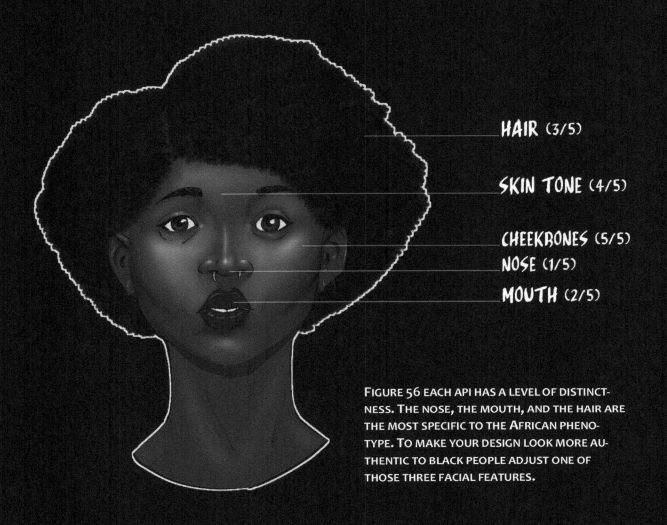

HAIR (3/5)

SKIN TONE (4/5)

CHEEKBONES (5/5)
NOSE (1/5)

MOUTH (2/5)

FIGURE 56 EACH API HAS A LEVEL OF DISTINCT-
NESS. THE NOSE, THE MOUTH, AND THE HAIR ARE
THE MOST SPECIFIC TO THE AFRICAN PHENO-
TYPE. TO MAKE YOUR DESIGN LOOK MORE AU-
THENTIC TO BLACK PEOPLE ADJUST ONE OF
THOSE THREE FACIAL FEATURES.

The rule of 3/5ths is a rule of thumb that can be used to both identify African ancestry implied in a design but also for adjustments as the character visually develops.

Adjusting an API in your design to be more distinct elucidates the character's intended race or obscures it depending on your intent.

The African diaspora is diverse and black American descendants of slaves have mixed heritage from various countries in Africa. Reference whatever region you are basing the character's origins on for accuracy but relying on the rule of 3/5ths bridges the gap between style and reality

THE DIAMOND METHOD

FIGURE 57

The diamond method builds the face from the nose outward. The d sired size and shape of the nose (outlined by a diamond shape fig. 57) inform the placement of the eyes, the width of the mouth, whi allowing the freedom to adjust the cheekbones and jawline as needed

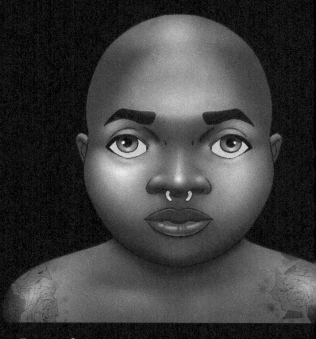

FIGURE 58

The nose is the focal point of the face. The size and shape of a person's nose informs the proportions and overall shape of a face.

Of all five African phenotype identifiers, the nose is the strongest visual indicator of African ancestry. Even if the other 4 API make the design look racially ambiguous, a strong African nose will always translate.

A fantastic way to construct faces with African features in mind is something I call **the diamond method**.

First, get acquainted with the diamond shape. The most important thing to know is that the shape can and should be adjusted to create several types of faces. Think of the diamond as a three dimensional object. The center point represents the tip of the nose (fig. 59) and thus indicates the direction the face is pointing.

The bottom quadrants of the diamond shape are placeholders for the nostrils. The top and bottom points of the diamond indicate the places where the protrusion of the nose begin and end; same goes for the outer points along the horizontal line.

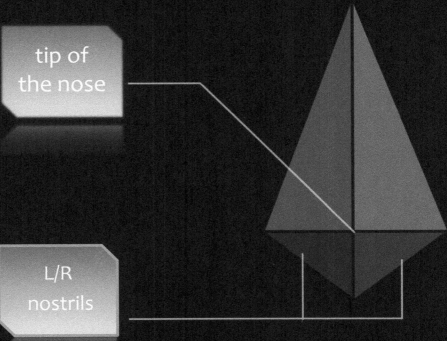

FIGURE 59 KEEP IN MIND THAT WHEN USING THE DIAMOND METHOD, THE WIDER THE SPACE MADE FOR NOSTRILS THE WIDER THE FACE WILL BE. THE LONGER THE VERTICAL LINE THE LONGER THE FACE WILL BE. ALWAYS MONITOR THE PROPORTIONS OF THE FACE.

When you feel confident enough drawing and using the shape from multiple angles, move on to the tutorial on the next page.

FIGURE 60

Step one: Draw the diamond shape. Use whatever method or tool that you might need. In the supplemental files you will find a PNG file with a transparent background that you can use if you would like to follow along. Keep in mind that your design needn't come out like mine.

The method I use to build the diamond starts with the vertical line followed by the horizontal. The higher the horizontal line is on the vertical axis the more the nose will point into the air

FIGURE 61

Step two: At the top point of the diamond, draw a horizontal line. Make this line as wide as you intend the face or head to be. Try to keep this line as equally divided as possible with the tools you have. Be prepared to adjust if the features look off.

Step Three: from the left point of the diamond, draw a vertical line upward until it connects with the eyeline made in step two. From the same left point, draw a diagonal line that extends into infinity; that line should be on the same trajectory as its point of origin.

From the eyeline, draw a vertical line downward until it meets the diagonal line you just made. Repeat this process on the right until you have a grid that looks like the one in the step 3 example.

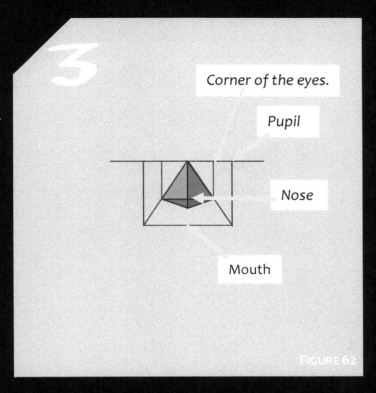

Corner of the eyes.

Pupil

Nose

Mouth

FIGURE 62

Step Four: Use the facial grid to draw in the facial features. Add any additional information like eyebrows, piercings, etc.

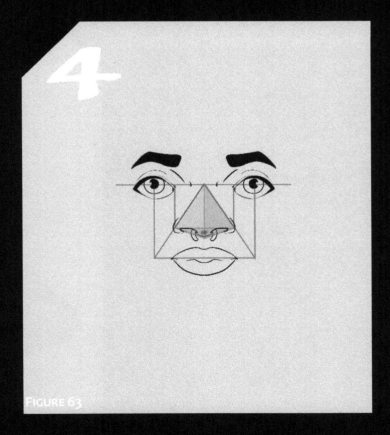

FIGURE 63

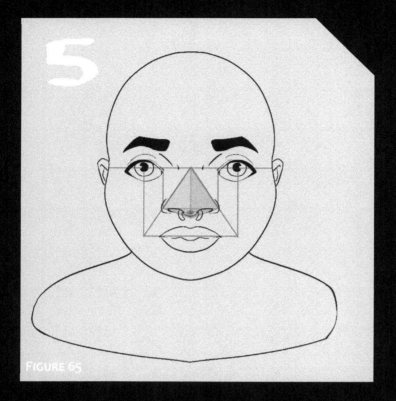

FIGURE 65

Step Five: Draw in the shape of the face. Use the eye line to guide how wide the face is at eye level.

Step Six: Finish the rendering.

The diamond method is a great guideline for drawing any phenotype however the diamond shape itself suits

African features very well

FIGURE 64

The African phenotype is remarkably diverse while at the same time being very distinct. Because Black people can be born any hue, from lightest to darkest, relying solely on skin tone is not reliable.

As much as it makes us stand out, Black people are more than just melanin. Our facial features carry our history and give us insight on ancestry that was stolen from us.

FIGURE 66

African Phenotype Identifiers and the rule of 3/5ths are tools for adjusting designs to be more authentic to Black people. The diamond method is a unique method for building up Black character designs from scratch.

REMEMBER

The same concept of gender presentation applies to facial anatomy.

Pronounced features are not inherently masculine nor are quaint inherently features feminine.

In Black Cultures, strong unique features define beauty.

With all that said I have one caveat: *Black people do not all look alike.*

Understanding that black features are not only culturally significant but also complex results in more nuanced designs. Reference what you can via google images, pinterest, imgur, or any other image-based platform, but familiarize yourself with the big and subtle difference throughout the African Diaspora.

HOT TAKE:

Lion

Hello, my name is Lion and I am going to introduce black facial anatomy. As a portrait artist, it is crucial to understand how to draw distinguishing characteristics as well as basic portrait proportions. This is a digital tutorial and I work with Photoshop CS6

The tools I will be using are:

Kyle Webster Megapack,

The brushes I will be using are

Ahmed Aldoori photoshop brushes

FIGURE 67

How to Draw Black People

STEP ONE:

There is a reason people say that the eyes are the windows to the soul. Eyes capture attention and express emotion in a way no other feature on the face can. Drawing the eyes incorrectly or lopsided immediately detract from your drawing. An eye is composed of four principal parts: Eyebrows (red), Upper lid (blue), Eyelashes (purple), and Lower lid (green). In f1. I have gone ahead and labeled each part for you. Manipulating the size, thickness, and shape of these parts is what gives eyes their uniqueness.

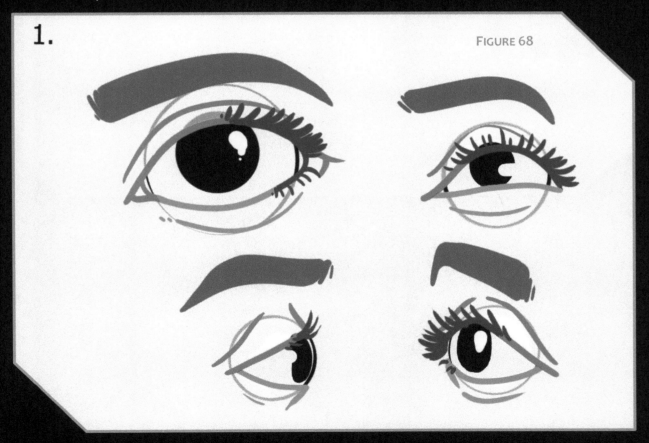

1.

FIGURE 68

STEP TWO:

Value and shading take your art from flat 2-D to a more realistic 3-D. Most artists will start off working with only black, white and gray your art first to make working with color easier. In this step, I have colored in the eye from figure 67 using both grayscale and color. Note that in both examples how the values take a flat image and add the illusion of depth and roundness.

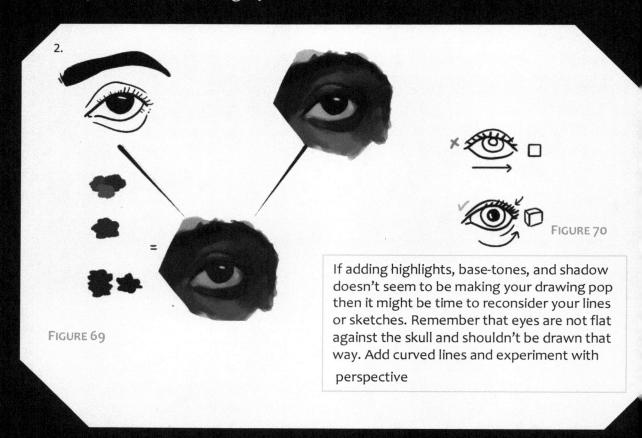

2.

FIGURE 69

FIGURE 70

If adding highlights, base-tones, and shadow doesn't seem to be making your drawing pop then it might be time to reconsider your lines or sketches. Remember that eyes are not flat against the skull and shouldn't be drawn that way. Add curved lines and experiment with perspective

before they learn how to use colors. Shades of black white and gray help artists easily transition from the lightest points of a drawing to the darkest without having to worry about the complexities of color theory. Coloring in grayscale first can also help you map out the shad-

When working digitally it might be tempting to color your art in grey and simply color the layer above your shading. This will make your colors muddy and unrealistic. My recipe for coloring (fig. 68) is to have three colors for the highlights, a base color to start, and three col-

STEP THREE:

While noses can come in any shape or size it's no secret that black noses tend to be on the wider side of the spectrum. Here is an easy shape you can create to shape your noses. The blue represents the bridge of the nose which tends to be straight and flat on Black people. The red represents the sides while the yellows help guide where the nostrils are located at the bottom. Note how the shape is narrow at the top before sloping outwards. This is true for most black noses. There are exceptions to every rule.

Like with any part of the body how much of each side is seen depends on the angle at which you are viewing. Note how the shape and size of each of the four parts change when viewed from the front, the side, and from a 3/4th angle (fig. 70-71).

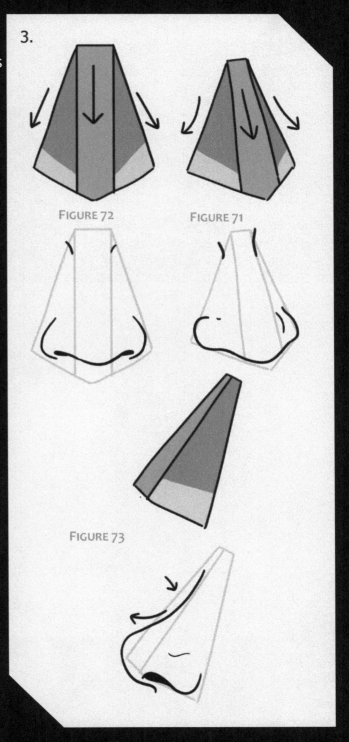

3.

FIGURE 72 FIGURE 71

FIGURE 73

STEP FOUR:

Shading noses is fairly simple. In figure 72 I went ahead and shaded the nose drawn in step 3. When looking at a nose straight on you will notice that the highlights of the nose are where the nose juts out the most. The fleshiest part of the nose will carry the lightest colors (as it sticks out the most) while the sides, nostrils, and bottom of the nose will carry the mid tones and shadow colors.

copies of one another. It doesn't take being an expert to know that if the person you are drawing is predominantly black then their features and skin will reflect that. However Black people can also be bi or multiracial and have features that show this as well. For this reason, the most important and most accurate thing you can do when drawing Black people is to use a reference when drawing.

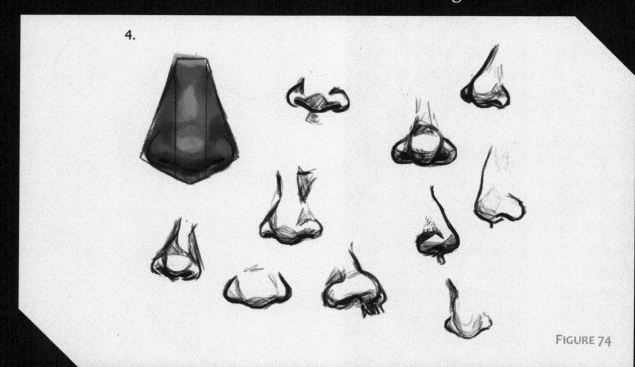

FIGURE 74

STEP FIVE:

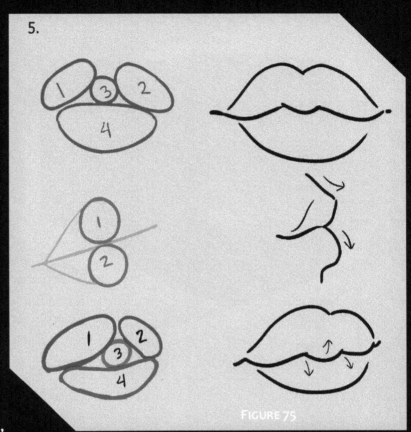

5.

FIGURE 75

Regardless of which angle you look at the lips they always preserve their roundness, and this is what makes them look three dimensional. Avoid straight lines when drawing lips.

Lips add character to a face. They can be long, full, lopsided, thin, small, or large. Essentially lips are made of four parts as seen in figure 74.

The top 3 circles make the top lip while the larger fourth shape creates the entirety of the bottom. Play with the size and width of these four parts to create any lips you can imagine.

There is no excuse for exaggerating lips or making "chinless wonders" by placing large lips at the very bottom of the face. A long history of artwork exists that enforces racist and discriminating ideas about what Black people look like, an artist should always strive to never misrepresent or mischaracterize their subjects by making them into harmful caricatures. As an artist, you are responsible for the ideas conveyed in your work.

STEP SIX:

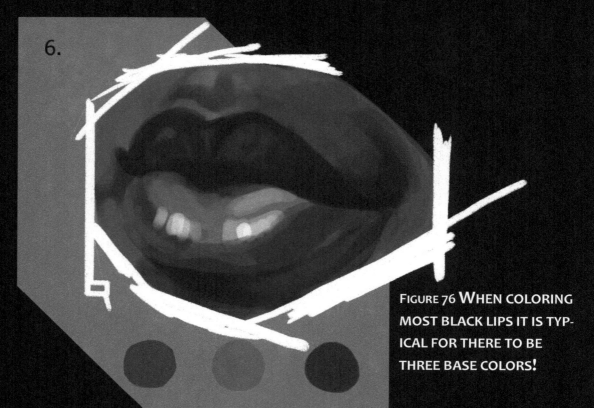

6.

FIGURE 76 WHEN COLORING MOST BLACK LIPS IT IS TYPICAL FOR THERE TO BE THREE BASE COLORS!

Lip colors range from dusty browns to bubblegum pinks and soft mauves. Getting the combinations correctly will take practice at first. The darkest colors tend to be purples and browns, and you will find these most on the top lip. These colors are mostly found on the top lip and they will always make it darker than the bottom lip which holds the most highlights and pinks. Like with the other features of the face you will need to use a range of shades values, and tones to create the illusion of depth. Lips come out and away from the face causing slight highlights on the cupids bow and shadows over the chin depending on how large the bottom lip is. When coloring lips you should avoid giving Black people lips that look like donuts as this is typical in caricatures. When coloring you should not give Black people bright tan, red, or pink lips unless for a specific reason.









Now let's add the shapes we covered in the previous steps (fig. 77) The proportions of the face take time to learn and can be hard to get right without the use of reference.

Here are the basic tricks: The inner corners of your eyes are also where the edges of your nostrils start. The outer corners of the eyes are where your neck starts.

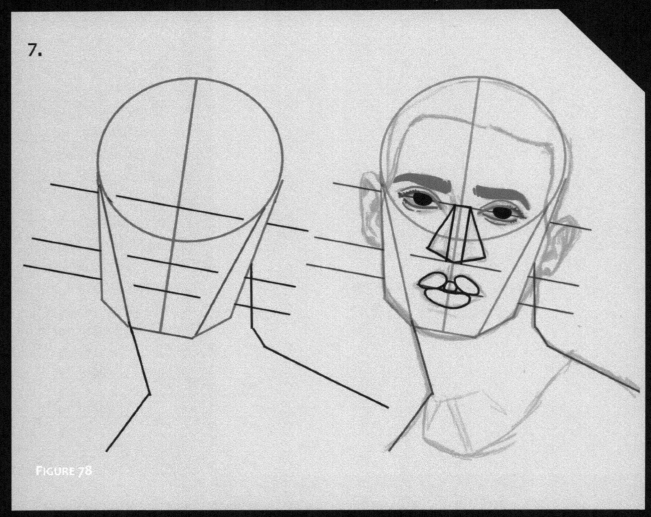

7.

FIGURE 78

Setting up the eyes properly will help you proportion the rest of the face.

The distance between the eyes is the same length as one singular eye. Ears are mostly located between the eye
brows and the bottom of the nose.

Lastly, the pupils will sometimes fall in line with the outer corners of the lips.

STEP EIGHT:

Your finished portrait won't always be the cleanest sketch or even the most correct (fig. 78). This is fine. Make sure to go back into your artwork and check for mistakes before you proceed to adding colors to prevent being complete but unsatisfied

bottom of the nose, lips, and beneath the chin will carry the most shadows if your light source is coming directly from the front. The cheeks, foreheads, bottom lip, and the tip of the nose catch light the most.

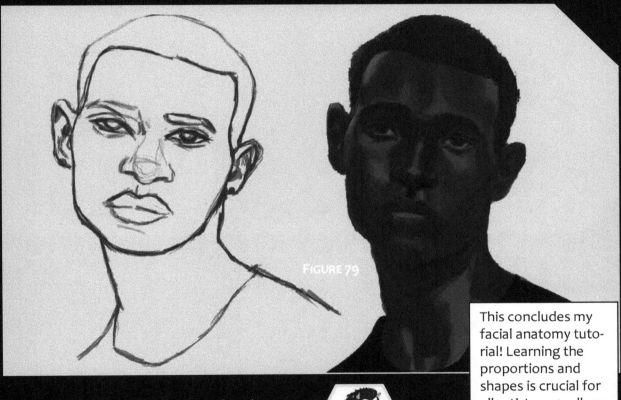

FIGURE 79

with what you have created. When coloring, take the planes of the face into consideration. Feel your own face. Which parts protrude? Which parts sink in? Familiarizing yourself with your face teaches you where shadows, highlights, and all colors between should go. The eyes, the

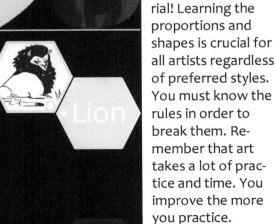

This concludes my facial anatomy tutorial! Learning the proportions and shapes is crucial for all artists regardless of preferred styles. You must know the rules in order to break them. Remember that art takes a lot of practice and time. You improve the more you practice.

ACTIVITY#5:
Am I drawing black face?

For this activity I want you to draw a black person, most specifically a face.

FIGURE 80

The 5 strongest African phenotype identifiers are (from strongest to weakest):
1. Nose
2. Lips
3. Hair
4. Skin tone
5. Cheekbones

Without using reference, draw a Black character as you always would have. Take the drawing to completion or at least the first few steps of your coloring process. Change the base color of your character to the same hue you would use for white characters. If the racial identity of the design still translates, great! If

not use the rule of 3/5ths to adjust the facial features until the character has at least three of the five APIs. The African phenotype is most recognizable through the nose;

however, it takes a combination of features to make the most authentic designs.

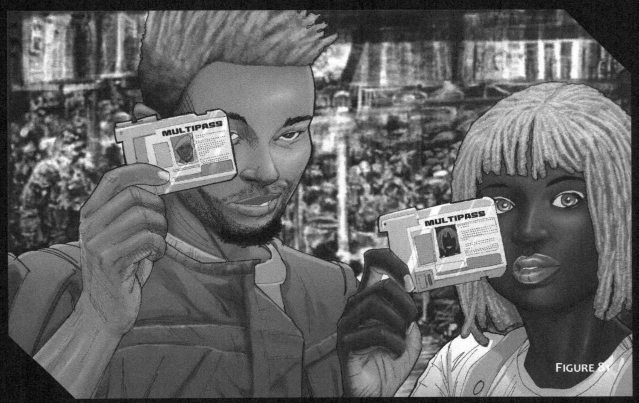

FIGURE 81

CHAPTER SIX: COLORING BLACK CHARACTERS

The color of colored people isn't as simple as black and white (truthfully, black and white aren't even colors but that's a topic for another book). There are complex dynamics at work that effect Black people based on the lightness or darkness of skin.

The decision is up to the designer, how dark or light a Black character's skin is; and that decision shouldn't be made flippantly.

Beyond the social aspect, dark colors react differently to light when compared to light colors. In this chapter I explain my techniques for rendering darker hues and outline the effects of **colorism** on character design.

WHAT IS COLORISM?

Colorism is an implicit bias for light-skinned people and or an implicit bias against dark-skinned people.

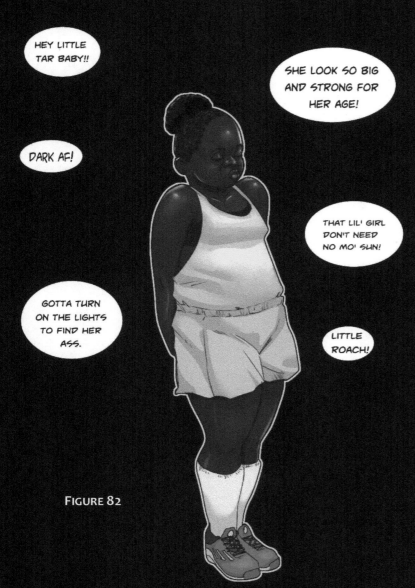

FIGURE 82

For Black people, colorism is a hot topic with many sides, for artists it is another layer to consider when designing. Culturally, the darkness of a black person's skin shapes their experience from birth into adulthood. So, the decision of how light or dark skinned a character is comes with a lot of responsibility. Associating dark skinned characters with evil and light skinned characters with good is a form of colorism. The answer, however, is not to exclude darker hues from the design palette.

Implicit bias aside, there are some technical reasons for excluding darker hues from a color scheme. Dark tones can disrupt the contrast of a design if they aren't planned for.

The problem with that logic is the more "light" added, the color tips toward its true color (fig. 83). Instead of a human skin tone, the result will always be colors not only inauthentic to Black people, but humans in general.

The cultural context of skin tone is complicated and difficult to explain and even more difficult to navigate. But that difficulty isn't something to shy away from.

FIGURE 83 IN THIS IMAGE THE SKIN TONE GETS AWAY FROM ME TURNING LAVENDER AND PURPLE. BLACK PEOPLE CAN BE VERY DARK BUT WHEN IN NEUTRAL LIGHT THE COLOR OF DARK SKIN DOES NOT TURN PURPLE, PEACH OR PINK.

Sometimes you have to get things wrong before you can figure out how to do them right.

AFRICAN PHENOTYPE COLOR PALETTE
(APCP)

This is the African Phenotype color palette. It consists of twelve color groups to use for skin tones.

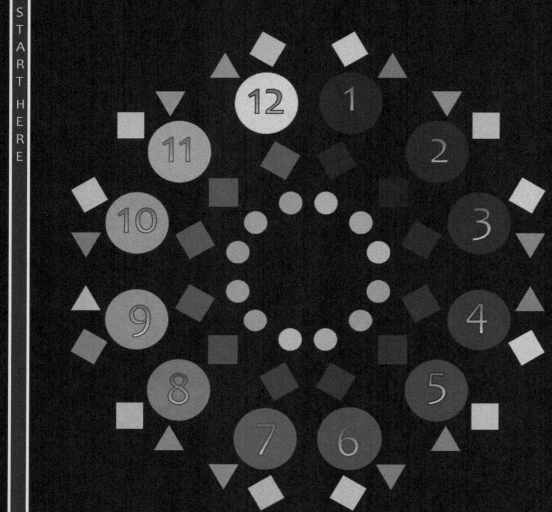

FIGURE 84 THE AFRICAN PHENOTYPE COLOR PALETTE IS A PALETTE COMPRISED OF BASE COLORS MADE FROM THE SKIN TONES OF BLACK PEOPLE; 1 DARK, 1 MEDIUM, 1 LIGHT, WARM OR COOL GRAY; AND A FLESH TONE. THE HSV/HEX CODES FOR THESE COLORS CAN BE FOUND IN THE INDEX

Let's begin with a guideline for choosing skin tones that are found within the African Phenotype.

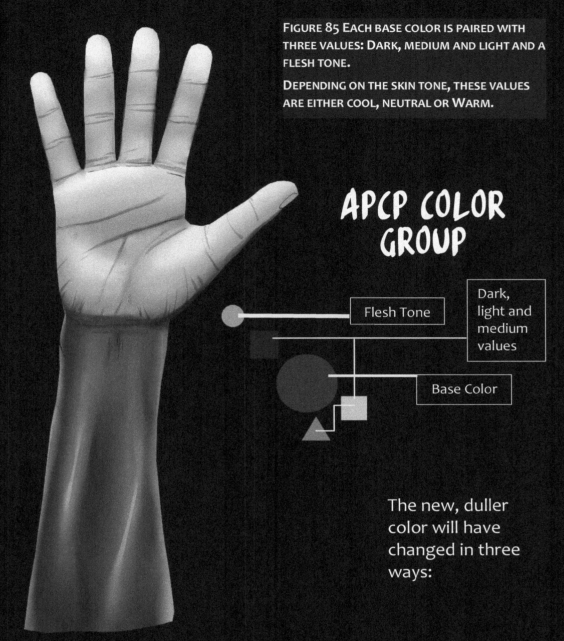

FIGURE 85 EACH BASE COLOR IS PAIRED WITH THREE VALUES: DARK, MEDIUM AND LIGHT AND A FLESH TONE.

DEPENDING ON THE SKIN TONE, THESE VALUES ARE EITHER COOL, NEUTRAL OR WARM.

APCP COLOR GROUP

Flesh Tone

Dark, light and medium values

Base Color

The new, duller color will have changed in three ways:

Color is a combination of three factors working together: **Hue**, **value** (or luminosity) and **saturation**. The APCP (fig. 84) works on the idea that when two different hues are blended together, they create a new, duller color.

1. The hue will change
2. The value will lower
3. The saturation will lower.

Using a color group from the APCP such as the one in figure 85 the color change can be controlled, and the base color rendered without losing control of contrast/saturation.

ABOUT COLOR THEORY.

Color theory attempts to conceptualize the way color reacts to light and the way the human mind interprets it. Setting aside the philosophical stuff, the scientific portion of color theory holds principles that can be relied upon. Fully desaturated, every color is reduced to a value and light responds to the value more than the saturation. So, the lower the value of a color the less light (as well as the color of the light) will be reflected. When light reflects off dark skin, it is partially absorbed and the color/light the skin reflects back is duller and closer to the skin's natural color. Replicating the effect light has on dark skin requires an understanding that light reflects less brilliantly on dark skin, and that unlike like lighter skin tones the base color changes less.

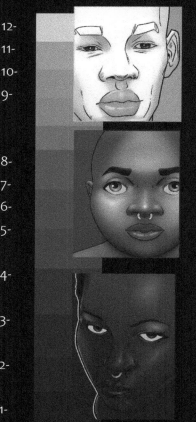

12-
11-
10-
9-

8-
7-
6-
5-

4-

3-

2-

1-

FIGURE 86 THE APCP (FIG. 84) IS ORGANIZED INTO SHADE CATEGORIES. THE FIRST FOUR SHADES ARE THE DARK SHADES; THE NEXT FOU ARE THE MEDIUM SHADES; A THE LAST FOUR ARE THE LIGH SHADES.

To explain how the APCP is meant to be used, a brief explanation of terminology is needed.

Firstly, for the purposes of this book the word "hue" is distinct from the word "color"

Think of hue as a container; inside that container are all the colors possible when the hue is mixed with white, black or any shade of gray in between.

A **color,** on the other hand, is a combination of two things: A hue and a value. What separates two colors o the same hue is the level of intensit [chroma, vibrancy, luminosity] and value [darkness, contrast, shadow] (fig. 87)

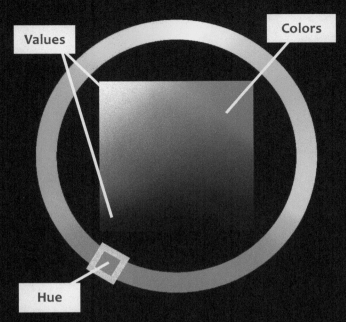

Values

Colors

Hue

FIGURE 87 THE OUTER CIRCLE IS CALLED THE COLOR WHEEL BUT THE MORE ACCURATE NAME FOR IT WOULD BE THE "HUE" WHEEL. YOU CAN OBSERVE THE RELATIONSHIP BETWEEN HUE, VALUE AND SATURATION BY MIXING COLORS AND PAYING ATTENTION TO THE THREE NUMBERS AT THE BOTTOM OF THE COLOR WHEEL IN CLIP STUDIO PAINT OR OTHER DIGITAL ART SOFTWARE APPS.

When mixing two colors of different hues, the hue of the new color will be similar to which ever color was more intense, and the value of the darker color will also be adopted.

Secondly, I use value to describe true black, true white, and all the shades of darkness in between. For example: The more value a color has the closer it is to a true white value and the less value a color has, the closer it is to true black.

Thirdly, I discuss light as an influence on skin tone and other objects and shadows

Painting digitally is done by manipulating light that is projected through a screen. Recognizing the relationship between light and color is especially important when working with dark colors.

Don't be intimidated by the jargon here's the TL; DR version:

HUE IS THE WORD FOR A CATEGORY OF COLORS.

SHADOWS ARE VALUES.

COLOR IS LIGHT.

With the terminology out of the way, let's unpack the techniques that make the best use of the APCP.

PREPARATION

In the introduction I explained that this book has a digital component. If you would like to follow along with each step of this tutorial you can find the steps in the supplemental cache that comes with this book.

This demo will be done in Clip Studio paint using the tools that come standard with the program.

Before you can begin, however, you must prep your canvas.

Following Along.

Non-CSP users can follow along using .png files found in the supplemental cache. The linework has a transparent background and can be imported into most digital drawing apps.

FIGURE 88

Prep steps:

1. Use the auto select tool to select the area outside of the line art; once done, invert the selection.
2. Use the fill tool to fill the selected area with one of the base colors from the APCP (do not deselect yet) This will be your flat layer, be sure to lock the transparency.
3. Create a new layer then create a mask by clicking the ⬤ icon in the layers sub menu.
4. Copy and paste the mask layer three times. You should have a total of four mask layers
5. Change the blending mode of the topmost mask layer from "normal" to "multiply"; do this for the other two mask layers but instead select "add glow"

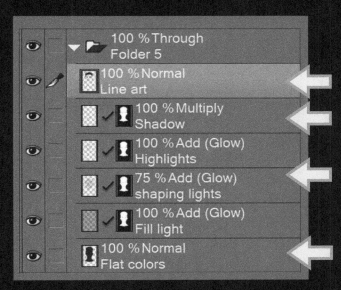

LINE LAYER

SHADOW LAYER

LIGHT LAYERS

FLAT LAYER

FIGURE 89 THREE THINGS OF NOTE:

1. THE SHAPING LIGHTS LAYER SHOULD BE SET AT 75% OR LOWER DEPENDING ON THE LIGHTING SITUATION.

2. IF YOU DO NOT USE BLACK LINES OR LINES AT ALL, LEAVE OUT THE LINE LAYER. USING THE LASSO TOOL TO MASK OUT STRATEGIC AREAS FOR RENDERING IS ANOTHER TECHNIQUE.

3. IT CAN BE HELPFUL TO LOCK THE TRANSPARENCY ON THE FLAT LAYER TO PREVENT "WRONG LAYER" ACCIDENTS

Arrange layers as shown in figure 89. Prepping a digital canvas is as important as prepping a physical one. This preparation routine can serve as a guideline to develop your own or you can use it as is. Make sure to integrate whatever process you use into your workflow. It saves time and makes finished work look more polished.

The mask layers allow for experimenting with techniques and blending modes while preserving flat colors.

If you are unfamiliar with this kind of process, take this time to play around with the color blending modes Clip Studio paint hast to offer. When you're ready, continue to the next page for the coloring tutorial.

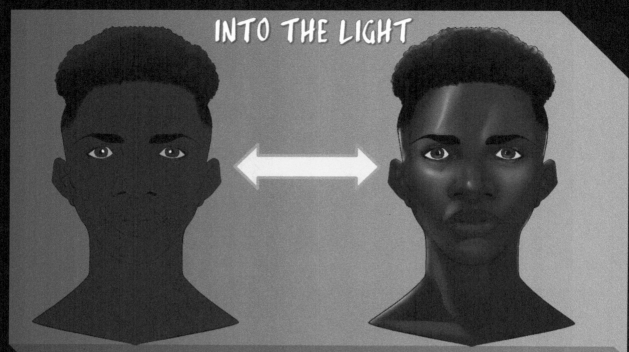

INTO THE LIGHT

For the darkest of skin tones, rendering light requires a unique approach.

The four basics steps for my technique are as follows:

1. FILL

2. SHAPE

3. HIGHLIGHT

The prep process (fig. 89) makes it easy to work from the bottom most layer toward the top. However, you can work these steps in any order that feels natural to you.

You can use any Base color from the APCP, but I've chosen the darkest color because if you can render light onto the darkest colors you can do so with any other color.

Let's start with the first and easiest of steps: Fill

1: FILL

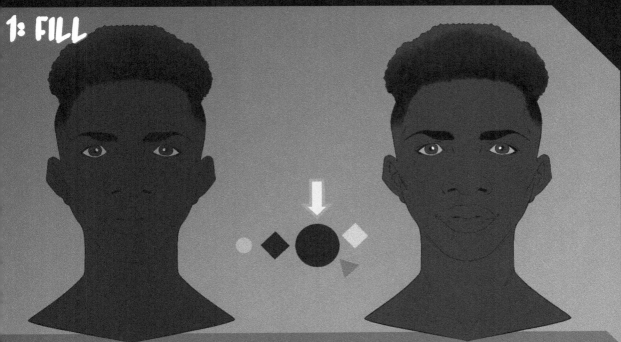

FIGURE 91 A FILL LIGHT IS AN INDICATION THAT THE LIGHT SHINING ON THE CHARACTER IS BRIGHT ENOUGH TO LIGHT THE ENTIRE ROOM OR AREA; SUCH AS A WELL-LIT BALL ROOM OR A PARK IN THE MIDDLE OF THE DAY. IF THE LIGHTING SITUATION WAS ONLY PARTIALLY LIT, OR DIM, THEN THE FILL COLOR SHOULD BE WHATEVER COLOR MATCHES THE PROMINENT LIGHT SOURCE.

Step one: Select the "Fill light" layer.

Then select the fill tool from the tool palette. In the tool properties sub menu, lower the opacity of the fill tool to 20%.

Use base color number one (fig. 84) to fill the layer.

The change should be subtle but it's also important. Be sure to think of your lighting situation, where the light is coming from and how close it is to the character you're drawing.

These factors determine whether or not you need a fill light or what color that fill light should be; they also determine other factors for later steps.

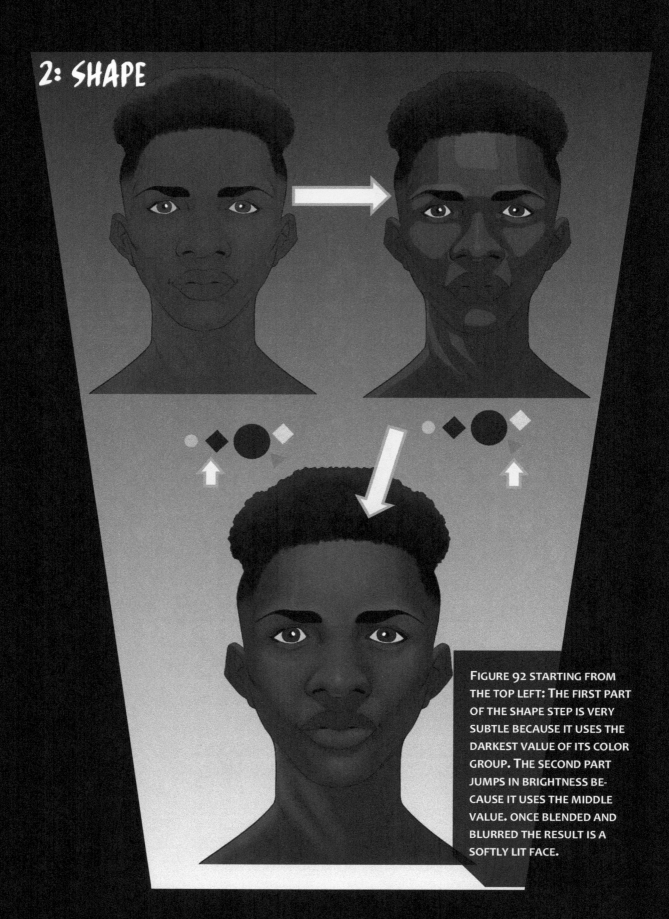

2: SHAPE

FIGURE 92 STARTING FROM THE TOP LEFT: THE FIRST PART OF THE SHAPE STEP IS VERY SUBTLE BECAUSE IT USES THE DARKEST VALUE OF ITS COLOR GROUP. THE SECOND PART JUMPS IN BRIGHTNESS BECAUSE IT USES THE MIDDLE VALUE. ONCE BLENDED AND BLURRED THE RESULT IS A SOFTLY LIT FACE.

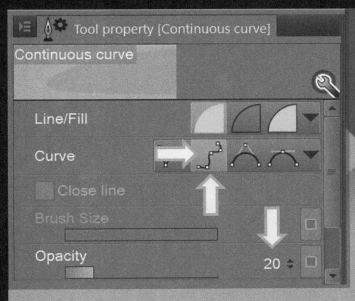

FIGURE 93 BE SURE TO SET THE CONTINUOUS CURVE TOOL TO "FILL". ALSO, SET THE CURVE TO "SPLINE" THIS WILL ALLOW YOU TO CREATE BOTH ROUND AND JAGGED SHAPES AS NEEDED.

Step two:

Select the "shape light" layer from the layers sub menu. Then, from the tool palette, select the "continuous curve" tool. (set the opacity anywhere between 15-20%.)

Use the continuous curve tool to shape the **hot spots** on the character's face. Keep in mind the direction of the light source, and how close the character is to it.
Shape the face in three phases (fig. 92). First, start with the darkest value from the color group. On the second pass use the mid

value to build up the topography of the face.

Lastly, use the blend or blur tool to even the shapes out and soften the edges where necessary.

FIGURE 94 HERE YOU CAN SEE THE SHAPES I USED TO CREATE HOT SPOTS IN FIGURE 92. THOUGH THE CHANGES ARE VISIBLY SUBTLE THEY SERVE AS A FOUNDATION FOR THE HIGHER VALUES THAT ARE APPLIED IN LATER STEPS.

3: HIGHLIGHT

FIGURE 94 INSTEAD OF IN-
TENSE BRIGHT SPOTS, THE
LIGHT IS MORE DEFUSED.
NOTICE THAT THE BASE
COLOR DOESN'T CHANGE
THE COLOR OF THE LIGHT.

Step three: Repeat the process used in step two, however, only use the mid and light tones from the color group (fig. 95)

The highlight layer should represent the brightest lights that will appear on the face. Keep in mind that dark colors reflect less color and light.

Only strong direct light creates intense bright spots on dark colors, and when it does, the color of the light is reflected rather than the dark color.

Because this layer is separate from the shape layer, feel free to start over if you feel like the contrast has gotten away from you.

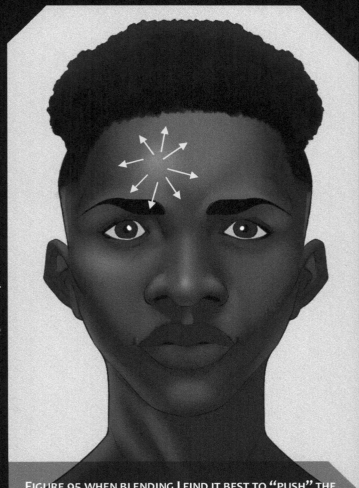

FIGURE 95 WHEN BLENDING I FIND IT BEST TO "PUSH" THE LIGHT AWAY FROM THE POINT OF CONTACT. I DO THIS TO MIMIC THE WAY LIGHT INTERACTS WITH THE PLANES OF THE FACE. WHERE THE FACE IS CONVEX, OR ROUND, SUCH AS THE FOREHEAD OR THE TIP OF THE NOSE, THE LIGHT WRAPS AROUND THOSE SHAPES THE SAME WAY IT WOULD A BALL OR A DOORKNOB. THE DIFFERENCE IN BRIGHTNESS OR REFLECTIVE LIGHT DEPENDS ON THE TEXTURE OF THE SURFACE.

4: SHADOW

FIGURE 97 THIS KIND OF LIGHT SCENARIO IS AKIN TO 3 POINT LIGHTING. THERE ARE SO MANY DIFFERENT PLANES TO THE FACE THE LIGHT *BOUNCES* AROUND AND CREATES DYNAMIC SHADOWS. AT THE FINAL STAGE, GETTING CONTROL OF ANY ISSUES WITH CONTRAST IS THE MAIN GOAL. SOFTENING BRIGHT SPOTS AND DARKENING SHADOWS IS THE NAME OF THE GAME.

How to Draw Black People

Step Four: This step is called "shadow", but the goal is to tighten up the contrast and make sure the light, medium and dark tones are distinct from each other.

Select the shadow layer and use the medium and dark values to add shadows opposite to the light source (fig. 97). Use either the continuous curve tool or a soft brush from the tool palette for this step.

You may need to switch back and forth between the "Highlight" and "Shadow" layers to get the values defined and separated (fig. 98).

Add any finishing touches like eye color or hair texture etc. Lastly, reserve the option to start over if you feel your blending, shadow or highlights have gotten out of control. The different layers make for safe boundaries to color within.

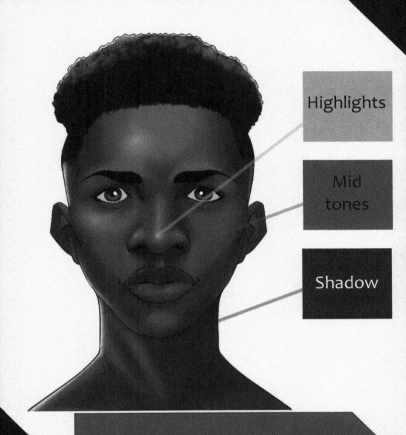

Highlights

Mid tones

Shadow

FIGURE 98 CHECK THE VALUES OF YOUR DESIGN BY CREATING "CORRECTION LAYER" (LAYER>NEW CORRECTION LAYER>HUE/SATURATION/LUMINOSITY). LOWER THE SATURATION TO ZERO, THEN MOVE THIS LAYER ABOVE ALL OTHER LAYERS. LEFT CLICK OR USE THE EYE DROPPER TO SELECT THE BRIGHTEST AND DARKEST PLACES ON THE SKIN (EXCLUDING LINE WORK). THEN, SELECT A SHADE OF GRAY SOME WHERE IN BETWEEN THE LIGHT AND DARKEST VALUES. IN A DIFFERENT LIGHTING SCENARIO, THE VALUES MAY NOT BE SO EVENLY SPREAD OUT. FOR THIS DEMONSTRATION SHOOT FOR THE SAME SEPARATION SHOWN HERE.

METHOD TO THE MELANIN

When scarred, skin our can grow back darker or lighter but not greatly.

The color of our palms and the soles of our feet are the same as our skin minus melanin.

Although some people have high levels of melanin in their skin, the color is made of the same hue.

Where skin is looser, such as at the knee or elbow, it gets darker when compressed.

FIGURE 96 CHOOSE IS BASE COLOR IS ONE IS ONLY ONE PART OF COLORING BLACK CHARACTERS. THERE ARE SUBTLE DIFFERENCES THAT GET GLOSSED OVER A LOT. THESE SMALL DETAILS ARE IMPORTANT ON A LARGER SCALE BECAUSE THEY HUMANIZE BLACK PEOPLE. STUDY THESE DIFFERENCES AND LOOK FOR WAYS TO INCORPORATE THEM INTO YOU DESIGNS. THE AFRICAN PHENOTYPE COLOR PALETTE IS ONLY ONE TOOL AT YOUR DISPOSAL, BE INNOVATE AND FIND MORE METHODS OR COME UP WITH YOUR OWN.

Black culture is as rich as it is complex. The taboos and mores shared among Black people are difficult to navigate from the outside looking in.

One of the biggest reasons' colorism has such a huge effect on the daily lives of Black people is the way we are represented in popular media.

The association of darkness with evil combined with a reluctance to create and or include authentic representations of Black people reinforces many terrible narratives about us.

It starts with artists and the decisions we make without knowing the possible outcomes.

Just as the visual stereotypes highlighted in chapter 2 are a part of a long tradition, so is the scarcity of dark skin characters.

The 12 colors found in the APCP is an example of how diverse Black people are chromatically. Use it as a guide or a place to start.

My technique is not the only way to use the APCP and I encourage you to experiment with your own methods. There is no singular way, or

mold to follow nor should there be for Black characters.

If there's anything I wish for you take from this chapter it's that being Black is a connective tissue, and each perspective is unique as it is valid.

Think carefully about the skin tone you choose for a character. The choice of skin color can imply a lot.

HOT TAKE:

LINDSEY SWOP

I'm Lindsey Bailey, an artist and illustrator known online as Lindsey Swop. I work in a

variety of mediums for the publishing, editorial, and illustration industry. My tutorial is about

black skin tone coloring.

The tools I will be using are: Adobe Photoshop CC and a 13" Wacom Cintiq

The brushes I will be using are: Mioree's Brush Collection 2017 "Hard + Soft Everything" brush

and "Airbrush"

STEP ONE:

I begin every piece with a rough but fairly accurate sketch to serve as a guide when I am painting.

This sketch does not need to be super clean because 99% of it will be painted over by the end of the painting, but I do place the anatomy correctly to serve as landmarks as I work.

For this painting, I will only be using the two brushes shown from Mioree's brush pack. The Hard + Soft will be used for: laying values, blending, and sketching. It also creates a great texture.

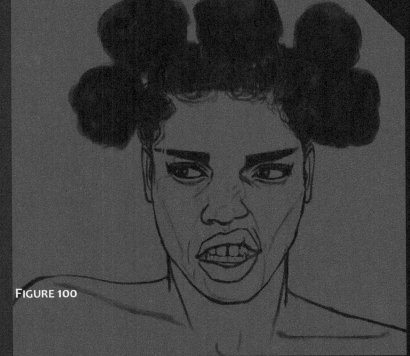

FIGURE 100

The airbrush is for laying down hues and lightening/darkening specific values if necessary. Any "pressure opacity" brush will work fine, and I often use the Photoshop default
brushes singularly for entire paintings. I've already completed the hair, a step I usually always finish with the sketch and left pretty minimal to focus on the face (fig. 100).

Let's jump into coloring.

STEP TWO: I use a method similar to traditional oil painting where there is a monochromatic underpainting and the colors are then glazed on in thin layers.

I began with a new layer underneath my sketch, and using the Hard + Soft brush, I painted a flat mid tone value first.

I never go 100% black with my shadows even with the deepest dark skin tones. Pure black should be reserved for such areas as the shadows in the hair, nostrils, pupils, eyelashes, etc.

The darkest shadows will be where one form meets another such as the neck and bottom of the chin and the outer nostril and cheek.

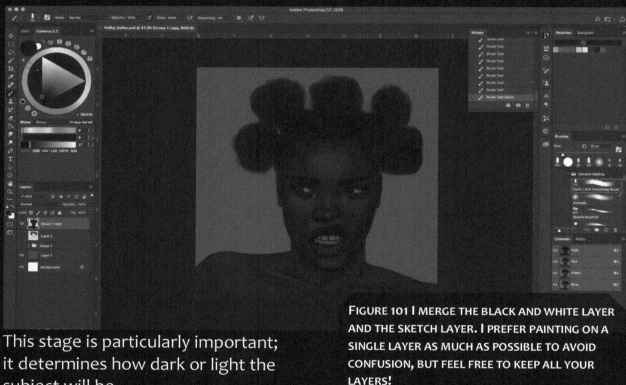

FIGURE 101 I MERGE THE BLACK AND WHITE LAYER AND THE SKETCH LAYER. I PREFER PAINTING ON A SINGLE LAYER AS MUCH AS POSSIBLE TO AVOID CONFUSION, BUT FEEL FREE TO KEEP ALL YOUR LAYERS!

This stage is particularly important; it determines how dark or light the subject will be.

I knew I wanted her to be fairly dark, so I went with about a 60% gray for the base. I then build the shadows with the mid tones (on the same layer).

Lastly, I add highlights. Just like with shadows, I never use 100% white for the highlights and reserve those for key areas (specular in the eyes and on the tip of the nose and, and in this case, the gold grill).

STEP THREE:

I use "Gradient Maps" to apply my first round of colors. I usually stick to two different Gradients Maps.

For those unfamiliar, Gradient Maps apply a customizable gradient of color to an image with 100% black represented on the left of the slider and 100% on the right.

I typically just stick to 2-3 colors max in my gradients. Pictured is the Gradient Map I chose as my base color.

I set this first Gradient Map on "Soft Light" layer mode and lower the opacity to 70%-80%. The base color is determined by the general under-tone I want for the skin: warm or cool.

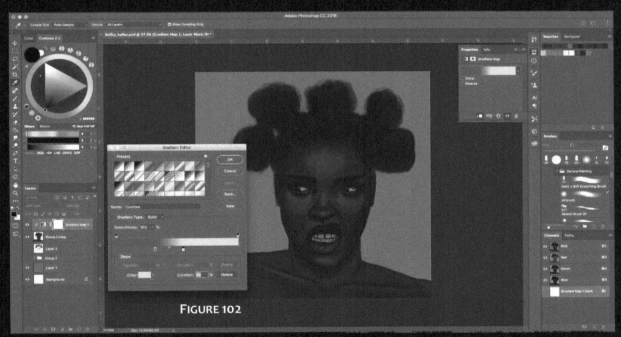

FIGURE 102

I've downloaded a ton of premade Gradients from the Internet, but you can easily take one of Photoshop's default gradients, select a color square and adjust the colors to your liking.

You can add dozens of assorted colors to the gradient by clicking below the gradient bar.

Warm browns, cool violets and cool grays all make great bases. Use reference, live models, or direct observation to determine these under-tones. Makeup tutorials for Black people are immensely helpful. For this painting, I chose a warm brown gradating to a medium yellow.

STEP FOUR:

The next step is another Gradient Map. This one set on "Hard Light" layer mode and lowered to 40%-50% opacity.

Using a single Gradient Map can render the skin tone flat and dull. I like to have variations in the skin, and I take advantage of that. My rule of

gradient map harsh and darken the image. Be sure to tweak the levels to bring your values back up and play around with the opacity of the "Hard Light" Gradient Map.

A layer mask is automatically added to a Gradient Map whenever you make one. Use black to mask areas you don't want affected by the Gradient Map. In this case, I masked out

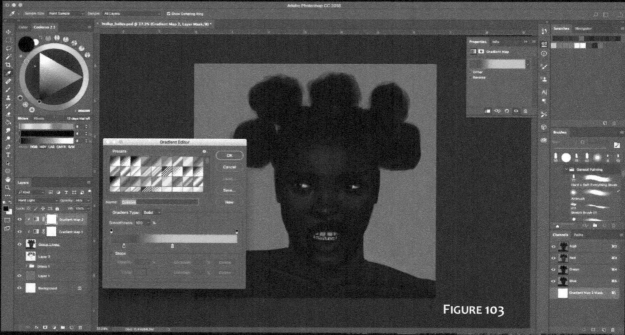

FIGURE 103

thumb is to have opposing temperatures on the skin. For example: warm highlights and cool shadows and vice versa.

For this painting, I chose a cooler color for the shadows (purple) and brought in orange to reinforce the mid tones and highlights. "Hard Light" layer mode can make this

the whites of her eyes and her teeth in both Gradient Maps to return them to a neutral color.

How to Draw Black People

STEP FIVE:

Even with two Gradient Maps, I still think the skin appears flat and not lifelike. So, after merging all of my color layers, I add another layer on top set to "Color" layer mode. Using the airbrush, I will apply distinct colors to select areas of the face.

tones, and the cooler zone in the lower face is more prominent in men than in women (5 o'clock shadow area). The best practice is to observe and experiment. Push those hue variations ever so slightly for more interesting tones or scale it back for a more subdued look.

FIGURE 104

The face has color zones. Though not applicable to all people, the forehead appears more yellow, the nose and cheeks appear redder, and from the upper lip down, the color becomes more gray or neutral.

I find that this does not hold true for everyone, particularly very deep skin

If I feel the variation is too strong, I will lower the opacity of this new color layer before merging it down.

STEP 6:

Now that we have colors in place, I begin the task of painting and blending. This can be done on a new layer on top of everything I've merged or on a new layer on top. I basically push the colors around keeping in mind those facial zones and the temperature contrast I chose initially.

I also use this stage to enhance colors that are rendered muter by color overlay layers and Gradient Maps, which were transparent and not opaque. I use my eyedropper frequently to pick up color in different areas to create subtle color variations and will tweak colors in the HSV slider either color or warmer depending on where it needs to be place.

Resist the urge to "over blend" and muddy the colors. Keep your brushstrokes minimal, and you'll really begin to see the beauty of your brushes!

Continue painting, being mindful to zoom out and check your values and colors. I save my brightest highlights for last, reinforcing the highlights I had slowly built up in previous steps. Color pick the

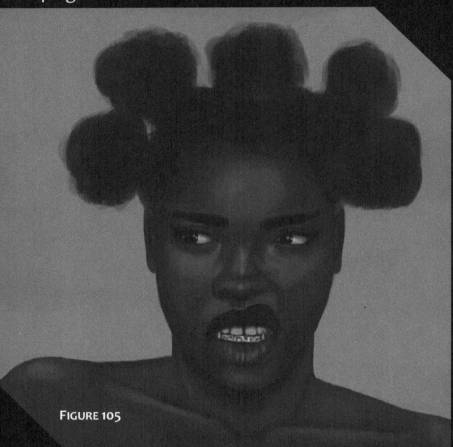

FIGURE 105

cheekbones and adjust the color incrementally in the HSV slider for the highlight. Remember to avoid pure white! Choose a color that has a hue and a few steps below pure white or it will look unnatural on dark skin.

STEP 7:

The steps above can be applied to all Black people with rare exceptions as noted. As the skin tone lightens, the hue variations become more apparent as the skin's translucency
increases. The opposite is true as the skin darkens and gains opacity. Study anatomy and where blood flows under the skin; where the skin is thin and thickest.

character will a lighter skin tone than the previous painting.
On the right I aimed for a very light skinned Black person with yellow undertones. I accentuated the red zones of her face on
the nose, cheeks and collarbones where the skin is thin and stretches over muscle and bone.

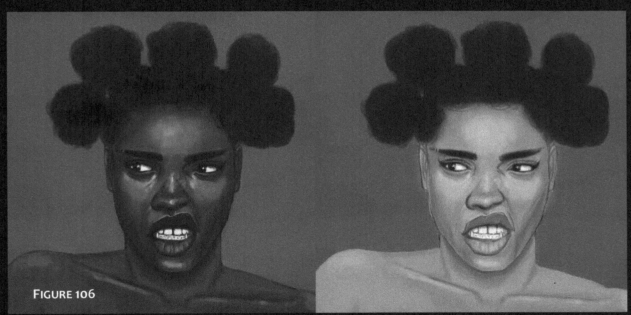

FIGURE 106

Observation is key to realistic skin tones for Black people.

Thin skin on the nose is where the skin appears warmer from blood flowing closer to the surface; skin color is warmer and more translucent around the ears.

Shine a light behind your ear to see. In this alternate color sketch on the left, I went for COOL highlights and warm shadows on a

ACTIVITY#6:

FIGURE 107

How to Draw Black People

In this activity apply all that you have learned thus far about: Pheno-type, Facial anatomy, and lighting dark skin tones.

FIGURE 108

This exercise works best if you choose a different lighting situa-tion for each bust.

Whether you use your own linework or the resources provided think of the diverse na-ture of Black people. Develop techniques for addressing vitiligo, albinism, stretch marks, and freckles.

Create a bust for twelve different Black characters using the African Phenotype Color Palette. In the sup-plemental files, I have included line work with transparent backgrounds that can be used if drawing isn't your forte. For Clip Studio Paint us-ers and Photoshop users there are CSP and PSD files with the line work pre prepped.

FIGURE 109

CHAPTER SEVEN: NAPPY ROOTS

How to Draw Black Hair

FIGURE 110

THE ART OF MALIK
SHABAZZ

One of the strongest African phenotype identifiers is hair. Coincidentally, hair is also one of the features designers struggle with the most.

The key to understanding kinky hair is its physical nature and the way

This chapter explains Black hair down to the individual strand and introduces techniques for creating Type 4 hair, the most common hair type among Black people.

MORE THAN JUST HAIR

FIGURE 111 THE CULTURAL CHARACTER PROMPT (PG. 10) CAN HELP DEVELOP IDEAS ABOUT THE TYPE OF HAIR STYLES THAT FIT A DESIGN.

Throughout the African diaspora, hair is chief among tools of cultural expression. When designing a Black character, the choice of hairstyle is equally important as the choice of skin tone.

For design purposes I divide Black hairstyles into 3 categories:

1. Fashionable
2. Protective
3. Low maintenance

To help explain each category I created a model I call Rosé (figure 111) you probably remember them from the facial anatomy chapter.

In the supplemental file cache, you will find practice files, featuring Rosé, that you can import to your preferred art app. You will also find guides for hairlines and a brush set I created specifically for Black hair.

The tutorials in this section rely on my brushes and the brushes were created with Clip Studio Paint. The HTDBP brushes can also be found in the Clip Studio Paint asset store. If you use a different program that has brush customization options, I have also included the brush tips from my brushes. The brush tips can be used to recreate my brushes in your chosen art app.

The differences between a hair style that is high maintenance or protective, are **hair type** and hair length. Hair length is self-explanatory (shoulder length, waist length etc.), but hair type requires definition (fig. 112).

The most common hair types for black people are:

1. 3c/4a
2. 4b
3. 4c

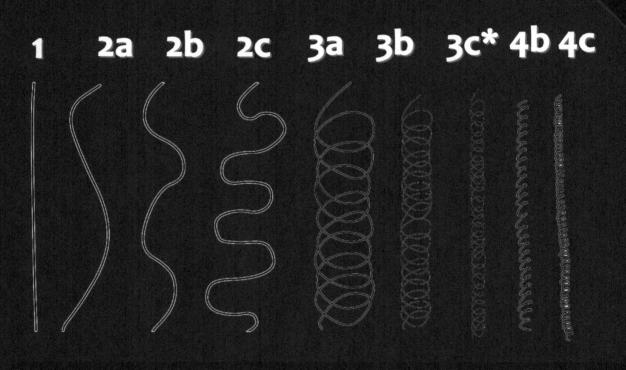

FIGURE 112 HAIR TYPES ARE DIVIDED BY THE NATURAL CURL OF HAIR. THE CURLIER THE HAIR IS THE HIGHER ITS CLASSIFICATION. BLACK PEOPLE CAN BE BORN WITH ANY HAIR TYPE, BUT 3A-4C ARE THE MOST COMMON AND NATIVE TO THE AFRICAN PHENOTYPE. *NOTE: 3C AND 4A HAVE A LOT OF OVERLAP; I GROUP THEM TOGETHER FOR SIMPLICITY.

Hair types (fig. 112) are mostly important to stylists, barbers, estheticians and make-up artists, yet they are useful to visual artists as well when designing Black characters.

This chapter focuses on 3c-4c hair types. With the help of Rosè let's take a look at the differences between hair types.

3A HAIR

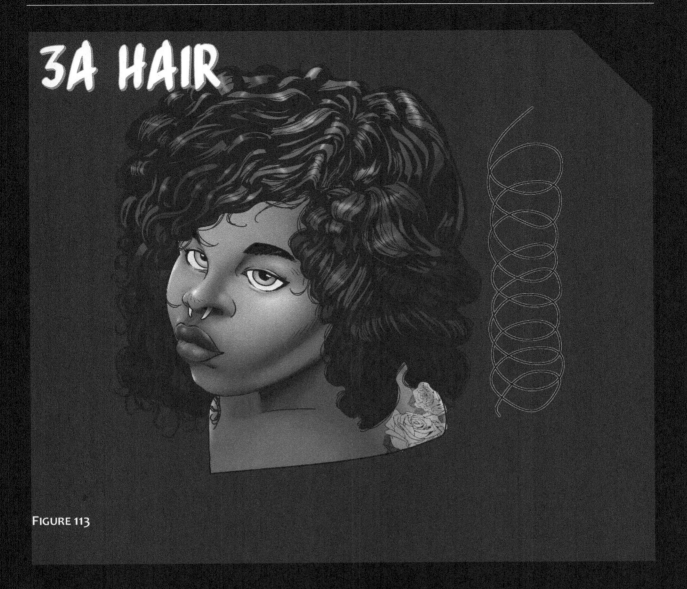

FIGURE 113

Un-styled, 3a hair can look a bit messy because of its large loopy nature. Dense but soft, this hair is capable of being styled in many different ways.

The coils of 3a hair are not sturdy, and the hair overlaps itself, collapsing under its own weight as the hair grows longer (fig. 113).

3a hair is a reference point for designing Black characters. Type 1 and 2 hair are not very prominent among Black people and therefore don't qualify as a strong African phenotype identifier. Focus on the other four remaining API (Nose, mouth, cheekbones and skin tone) to make your Design look more believably Black if you decide to use type 1 or 2 hair.

3B HAIR

FIGURE 114

3b hair coils twice as much as 3a hair. The tighter curls cause the hair to grow into structures at short lengths, but the longer the hair grows the more it falls to the shoulders. Natural 3b curls, combined with other African features, strongly indicate African ancestry.

At the same time, 3b hair is just as common outside of the African diaspora as it is within. If you are adjusting a design, hair of this type won't do the job by itself.

3C/4A HAIR

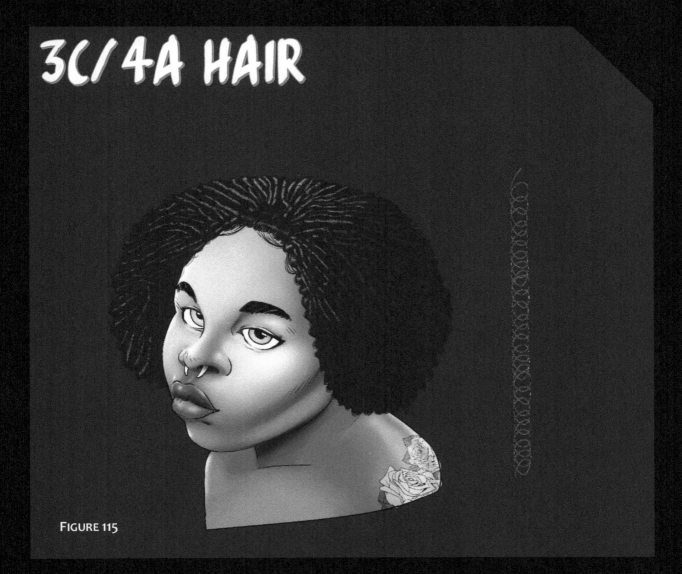

FIGURE 115

When hair grows into tight curls, those curls grow into structures of hair. The result is 3c/4a hair. the coils of 3c and 4a hair are strong, expand when moist, and shrink when dried out.

There is some bounce and movement, but mostly on the fringes of the hair.

3c/4a hair is common among Black people, and few non-Black people have this hair type. With regard to the rule of 3/5ths, hair with tight curls is a strong African phenotype identifier.

4B HAIR

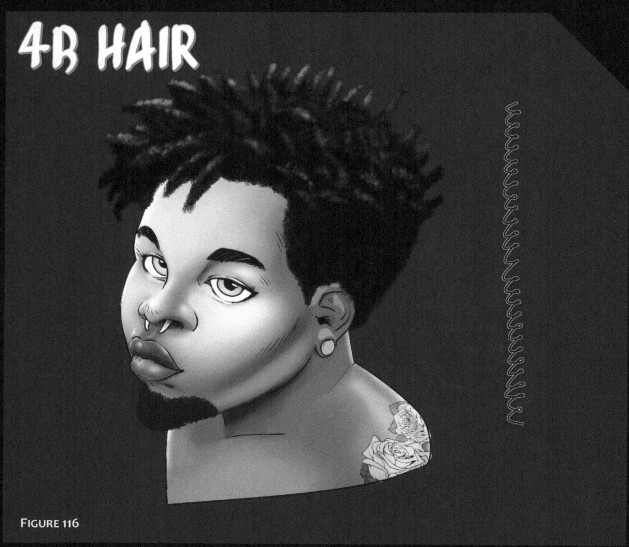

FIGURE 116

4b and 4c hair are strong indicators of African ancestry. In simplified designs, artists rely on the unique curl of type 4 hair to indicate Blackness.

Unlike other hair types, 4b/4c hair is made of curls so tight that they are hard to see from a distance. To an observer Black hair looks spongey and porous, but the tiny coils are only visible from close up.

The physical nature of type 4b/c hair makes it resistant to things like a gust of wind or an abrupt change of direction. The sturdiness comes from the elaborate structures of hair that naturally build upward and outward from the scalp; creating a forest of tangled and crisscrossing coils.

4C HAIR

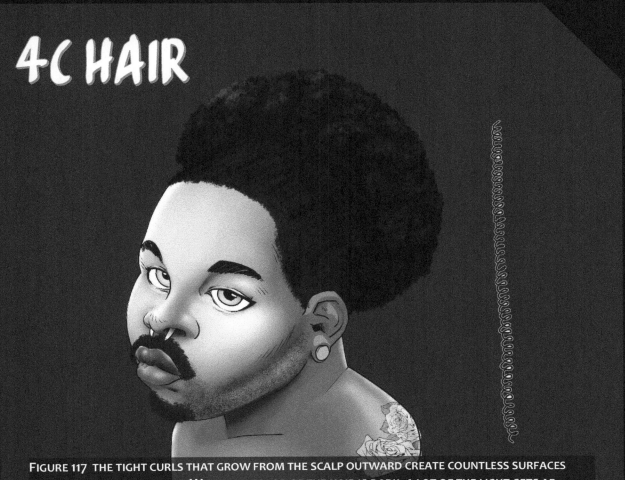

FIGURE 117 THE TIGHT CURLS THAT GROW FROM THE SCALP OUTWARD CREATE COUNTLESS SURFACES THAT LIGHT BOUNCES OFF OF. WHEN THE COLOR OF THE HAIR IS DARK, A LOT OF THE LIGHT GETS ABSORBED AND REFLECTS IN A DIFFUSED MANNER. LIGHT SPREADS ACROSS THE TEXTURE OF TYPE 4 HAIR IN A NON-UNIFORM AND SHIFTING PATTERN.

Take a moment to recognize how fundamentally different type 4 hair is from any of the other types. Sturdy, coiled, soft, resistant to motion and (most importantly) unique reaction to light.

Light travels through type 4 hair at the fringes, typically creating a halo; however, the texture of the hair creates deep intersecting shadows. The naked eye interprets the light and dark spots in type 4 hair as "static" or **visual noise.** The key to success when developing any technique to approach Black hair is believable or stylized visual noise (fig. 116-117)

DRAWING VS PAINTING

Coil brush A

Coil brush B

Coil brush C

Coil brush D

FIGURE 118 THESE SWATCHES WERE MADE WITH THE BRUSHES THAT COME WITH THIS BOOK. I MADE THEM TO EMULATE THE TYPE OF VISUAL NOISE THE HUMAN EYES SEE WHEN LOOKING AT LIGHT REFLECTING FROM TYPE 4 HAIR. YOU CAN CREATE YOUR OWN BRUSH OR METHOD BUT REMEMBER THAT DARK SURFACES REFLECT MORE LIGHT AND LESS COLOR. AS FOR THE TEXTURES THEMSELVES KEEP IN MIND THE CONSISTENCY OF TYPE 4 HAIR AND THE SHAPE OF THE CURL PATTERNS WHEN DESIGNING.

Any random type of visual noise will not do. To make type 4 hair look authentic the approach must be derived from the way light interacts with it. When light travels through the maze of curls and coils part of it is absorbed into the dark color (if the hair is dark enough) and the rest is diffused and dimly reflected.

The visual noise needed must be layered. The darkest hue or value serves as a base; followed by value or color that is half as dark; lastly Add another value that is at least 50% dimmer than the chosen light source (fig 118).

How to Draw Black People

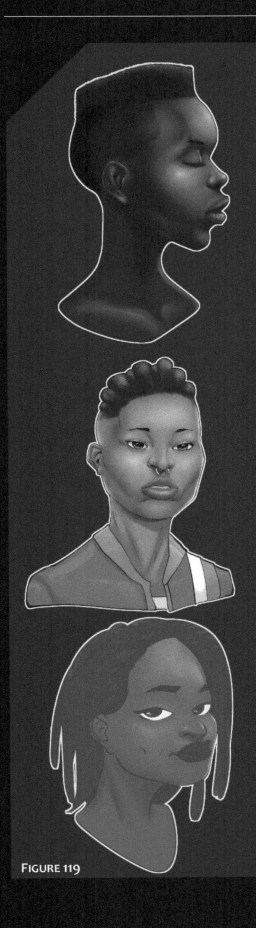

Here are some keys to focus on if your style relies more on painting than line work:

- The principles that govern dark skin tones govern all dark colors (less color from the surface and more from the light source).

-Emphasize the texture of the hair and build light up with visual noise (fig. 118)

-Focus on the overall shape of the hair first, then use texture to give it form.

-Keep the physical nature of type 3 and 4 hair in mind. At the base of the scalp, hair is sturdier and dense. At the edges, hair is less dense and more porous.

-Braids, twists, dreads etc. are all heavy. The thicker the loc or braid the heavier it is.

-Black people are born with the same hair color variety as non-black people; furthermore, Black people like to experiment with hair colors just like anyone else. Don't be afraid to incorporate unnatural colors like Lavender or Turquoise.

FIGURE 119

Coil Brush E **Coil Brush F**

Coil Brush G **Coil Brush H**

FIGURE 120 IF YOUR DESIGN RELIES HEAVILY ON LINEWORK, TONE SCRAPING IS THE BEST WAY TO ACHIEVE THE VISUAL NOISE EFFECTS THAT RESEMBLE 3 AND 4 TYPE HAIR. PICTURED ARE THE SECOND SET OF BRUSHES THAT COME WITH THIS BOOK ALONG WITH THE TYPE TYPES OF TEXTURES THEY MAKE. HIGH CONTRAST DESIGNS WORK BEST WITH THIS BRUSH SET.

High-contrast designs use a mix of digital painting techniques with physical media principles (ex: comic books, manga etc.). Black is used less as a value but more like a color. Type 4 in hi-con design is often approached as a uniform black shape. Crosshatching/tone scraping (fig. 120) is a technique used to create visual noise when a black value is involved. It isn't necessary to draw every strand of hair no matter what type it is.

However, a closer approximation can be made by cross hatching with hatch marks identical to the coils of type 4 hair. Similar to the painting method, the most important thing is re-creating the look of visual noise. The main difference is that painterly styles consist of gradients and shades, while line work relies on black or near black colors for lines and shadows.

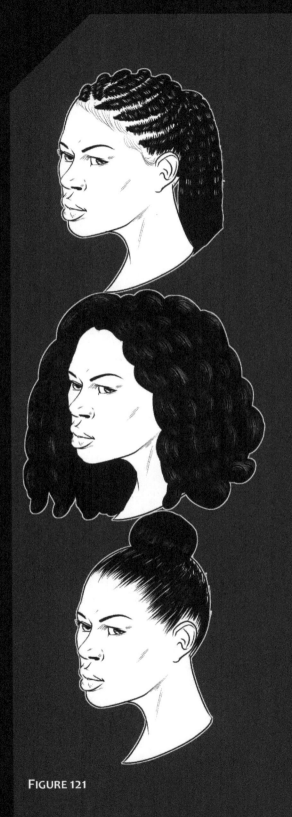

FIGURE 121

Things to keep in mind for a drawing approach:

-Be committed. Black people value hair a lot, culturally. Including intricate hair designs can be laborious but the effort is worth it.

-Keep track of the design of braid patterns.

-The soft hair around the hairline can be styled and implemented in a design.

-If using black, rely on negative space to indicate texture.

-Hair in Black culture is a tool of self-expression, be mindful of what the character may be saying with a specific hair style choice.

-Try to incorporate styles you rarely or have never seen before.

-Hair styles can be asymmetrical, messy or uneven; purposefully so, or otherwise. Experiment.

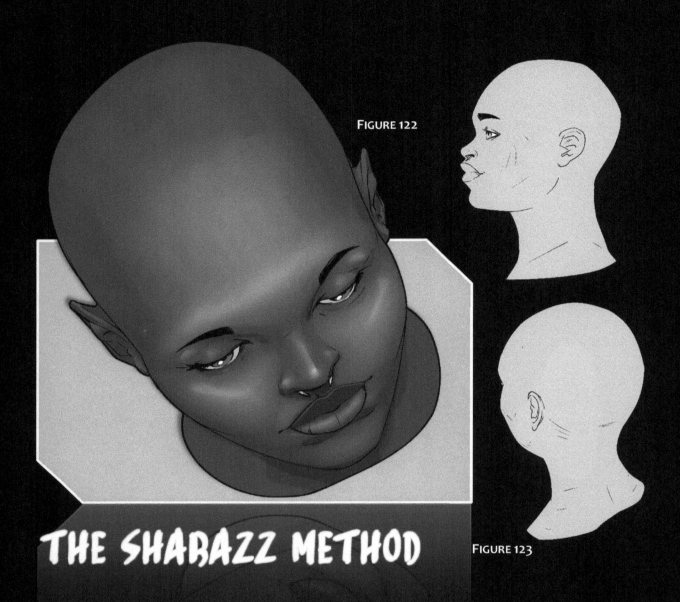

FIGURE 122

FIGURE 123

THE SHABAZZ METHOD

I use brushes I made specifically for re-creating type 4 hair. To get the best out of this tutorial I suggest using the brushes that come with this book. If you use Clip Studio Paint you can download the brushes directly from the assets store.

Search "HTDBP" or "SHABAZZ" in the assets store to find my hairbrushes. If you don't use CSP you can create brushes in your chosen program using the brush tips included in the supplemental file cache.

You will find the base model for this tutorial in the supplemental file cache. Use it and the other materials to practice hair styles and polish your techniques.

BALD FADE

Step one: Using the brush **"HTDBP hair 02"** cover the scalp of the character model in one pass. Visualize the hairline you want for the character, size of the forehead, etc.

Step two: Select a cross-hatching brush. (If you are using Clip Studio Paint, I suggest **cross-hatching x 3** from the standard brush set). Next, select the transparent color (checkered box) from the color palette.

Use the cross-hatching brush to "trim" the hair down into a nice buzz cut look.

Step three: Clean up the shape and form of the hairline and any leftover marks you have missed.

Tip: Save The Hair for Last. Unless the hair plays an important part of the composition, leave it as the last step before you finalize the design.

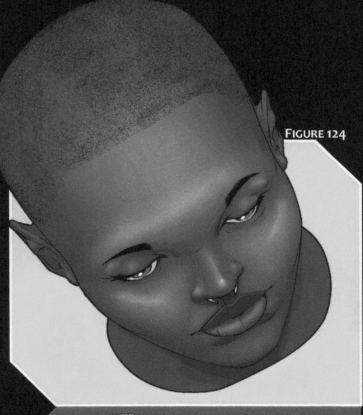

FIGURE 124

FIGURE 125

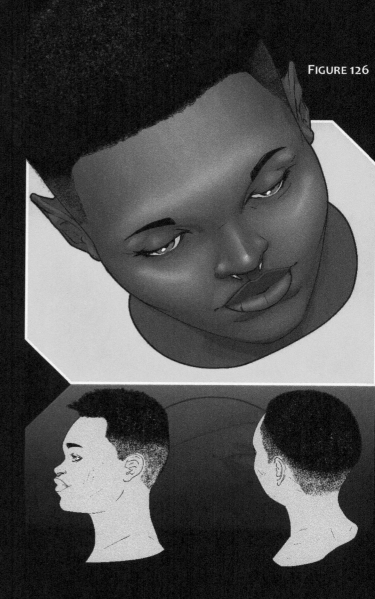

FIGURE 126

Step One: Repeat the first step from the bald fade (fig. 124) using **HTDBP hair 02** brush. Instead of doing one pass, layer your strokes, one over another, until you have created the desired form.

Step Two: Select a cross hatching brush and then select the transparent color from your color palette. Using the cross-hatching brush, pare down the sides and back of the head until you've created a nice gradation between where the hair is thinnest and thickest.

Step Three: Select a medium value gray from your color palette. Using **HTDBP hair 03** create visual noise in the places light touches the hair. If you are using the provided materials make sure the visual noise reflects the position of the light source indicated on the face (right above the character model.

AFRO

FIGURE 127

FROM TOP TO BOTTOM:

HTDBP HAIR 01

HTDBP HAIR 02

HTDBP HAIR 03

STANDARD

CROSS-HATCHING BRUSH.

Step One: Using the same techniques and brushes from the tapered fade, create the shape of the Afro you wish to create.

Step Two: on a separate layer, above the layer you were just working on, create visual noise with the HTDP hair 02 brush.

Step Three: Use a cross-hatching brush to form the texture of the hair

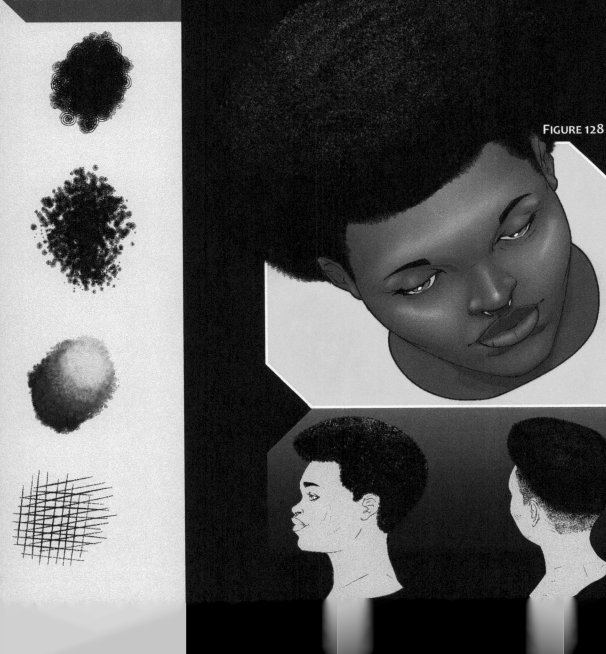

FIGURE 128

CORNROWS

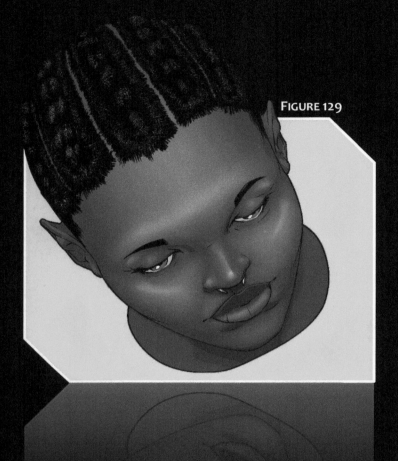

FIGURE 129

There are many unique styles for braiding Black hair and choosing a style shouldn't be done without rhyme or reason. One of the most commonly used style for Black character designs Is the cornrow style, named after the visual resemblance between the style and rows of planted corn on a farm.

Hair is divided into sections and then braided into knots that can be simple, complex or artistic. The braid follows the path in which hair is parted and the size of the division determines the thickness and length of the braid.

There are too many styles to cover in this book, but the process and understanding of cornrows can be applied to drawing any type of braided hair style.

FIGURE 130

The first thing to understand is that the braid pulls on the scalp and the tension can be seen both in between the divisions of hair and at the base of the braid.

The level of detail put into a character design varies so it isn't absolutely necessary to show this level of detail for the sake of authenticity.

Study the roots of braided hair styles from reference and decide how much detail is needed for your design to be successful.

Whilst figuring out the level of detail needed, avoid confliction in your design. Having a well thought out and detailed design for a Black character that falls short at the hairline is not only noticeable it's a bit embarrassing.

FIGURE 132

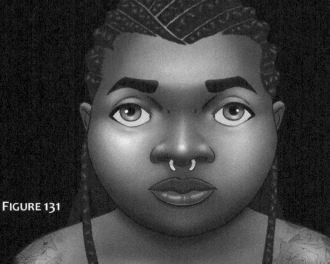

FIGURE 131

The dividing lines between braids are equally important as the braids themselves (if not more). Establishing how the hair is going to be divided before drawing or rendering the braids leads to more authentic designs, regardless of style.

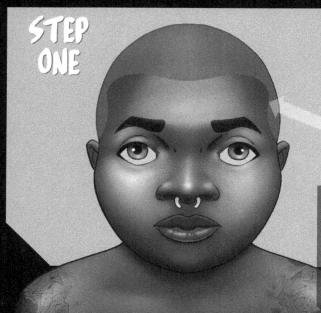

FIGURE 134 HAIRLINE TEMPLATES CAN BE USED FOR ANY HAIRSTYLE

Outline the scalp of the character design on a separate, upmost layer (fig. 133). I prefer to lower the opacity so I can see what I'm doing better but it isn't necessary.

FIGURE 133

On a separate layer, above the layer created in the previous step, fill in the area outlined by the hairline template. For regular cornrows, the next step would be to divide the hair into 4 or 5 different sections. These divisions or "parts" map out the direction of the braids. I've chosen a design that will have braids lain out in opposite directions, so I divided the hair into two parts.

FIGURE 135

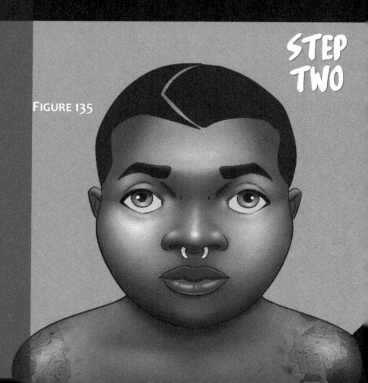

STEP TWO

STEP THREE

Divide the main parts into individual sections. Shape the sections into braids but leave them flat (lighting-wise). This step is for finalizing the length and shape of the braids.

FIGURE 135

Next, render the divisions of hair to imply weaving. The bigger the part, the bigger the braid. The bigger the braid the more defined are the divisions and vice versa. The size of braid I've chosen for Rosé requires a little detailing; if the parts were wider the opposite would be true.

FIGURE 137 REMEMBER THAT CORNROWS ARE BRAIDED FROM THE ROOTS OF THE SCALP. HINTING AT THE PULLING OF HAIR IN BETWEEN BRAIDS MAKES THE DESIGN LOOK MORE NATURAL.

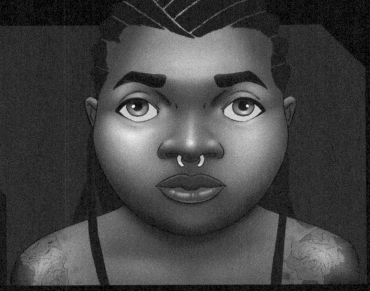

FIGURE 138

STEP FOUR

Create another layer above the rest. Set the blending mode to "add glow" and select a fine but soft brush from your tool palette. I've chosen a dark cool color for the hair and I decided to build the light up with a warm, medium gray. Use this technique to create the alternating patterns of reflected light.

FIGURE 136

FIGURE 137 YOU WILL FIND PRACTICE FILES IN THE SUPPLE-
MENTAL FILE CACHE THAT COMES WITH THIS BOOK. YOU CAN
RECREATE THIS TUTORIAL OR PRACTICE NEW HAIRSTYLES OF
YOUR OWN DESIGN FROM MULTIPLE ANGLES.

The best way to know how to draw anything is to understand how it works in real life. Learning how to draw Black hair takes a lot of time, patience and study. The techniques and brushes demonstrated in this chapter are only one part of the puzzle. An understanding of the different hair types and their corresponding textures is the other piece.

Character designers must be able to incorporate and simplify observable aesthetics and features, to varying degrees. At the same time, there are no short cuts that come without limitations. With other, straighter hair types, it is easier to imply an intended hair style. Not only are there countless designs to reference, but there are millions of examples in movies, television shows and advertisements. Whereas with Black characters not only is authentic Afrocentric hair hard to find, kinky hair is often omitted, even for the most popular of Black characters.

FIGURE 138

Ultimately, the difference between an authentic design that resonates with black audiences comes down to effort and detail. Make the right effort by putting in the time to get the culturally significant details right.

ACTIVITY #7:

FASHIONABLE

Fashionable styles are statements. They make characters standout and be noticed. With Afrocentric hair being fashionable can mean introducing colors, complex braid designs and curl patterns.

LOW MAINTENANCE

Styles that require little upkeep or handling are what I consider to be low maintenance. This can range from anything like a simple fade to natural styles the require less primping than fashionable ones.

PROTECTIVE

Durags, headwraps, buns, twists, braids, etc. Protective styles protect Afrocentric hair as it grows and or manages longer hair.

For the final activity, create 3 busts similar to the ones used in this chapter.

Each bust should be from of the following angles:

Top down.

Profile.

Over the shoulder.

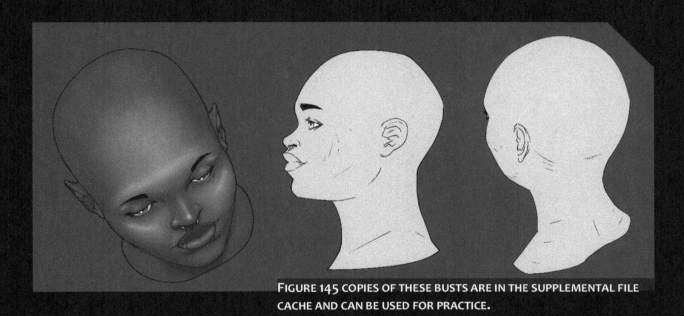

FIGURE 145 COPIES OF THESE BUSTS ARE IN THE SUPPLEMENTAL FILE CACHE AND CAN BE USED FOR PRACTICE.

For each bust create 1 protective style, 1 low maintenance style, and 1 fashionable using types 3a-4c (pg. 108)

Use your own brushes or the ones provided with this book.

APPENDIX 1:
COLOR CONVERSION
HEX CODES

How to Draw Black People

241C1F

2D1E23

121720

191718

757A83

8A8A9E

C3C8D3

C3C3CA

C0A4AE

C6ADB5

352526

43352A

232024

302E25

958F98

8E8D80

D2CCD5

D8D7CB

BDA4A8

CCB4AC

554031

614B39

343224

37352C

8D8B7D

8A887F

CBCBC0

CBC9C0

B79E97

B79E97

6F5444

423F37

959187

C3C0B7

CFAE9F

8C7A5F

544E43

96938C

C3BFB7

D7B9B1

A79071

B09982

5C5751

635B57

8E8882

8A817C

C3BDB7

D0C5BF

D7B89F

DDBEAF

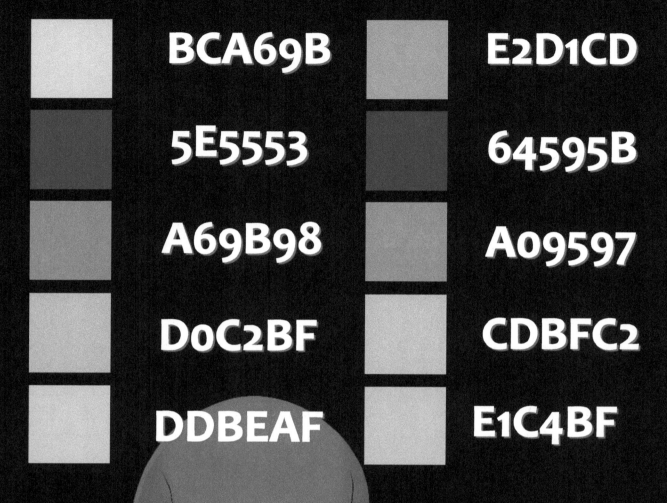

BCA69B

E2D1CD

5E5553

64595B

A69B98

A09597

D0C2BF

CDBFC2

DDBEAF

E1C4BF

How to Draw Black People

APPENDIX II: GLOSSARY

Acuity:
keenness of perception.
In this book acuity is used to describe the mental and physical abilities of a character, in relation to what is considered "common".

Aesthetics:
a branch of philosophy dealing with the nature of beauty, art, and taste and with the creation and appreciation of beauty.
The visual cues designers use to communicate information to an audience or viewer.

African Diaspora:
A term that describes Black people settled far from their ancestral homelands, as well as those still living in Africa.

African Phenotype Identifier (API):
A physical feature, such as hair or skin tone, that implies a character's visual relation to Black people.

Afrocentric:
Centered on or derived from Africa or the Africans.
This also refers to the African diaspora.

Androgynous:
having the characteristics or nature of both male and female; neither specifically feminine nor masculine; suitable to or for any gender.
For character design, androgyny is the combination or subversion of masculine and feminine visual gender norms.

Color Scheme:
a particular combination of colors.
Colors chosen strategically to associate a character with an emotion or mood.

Colorism:
prejudice or discrimination especially within a racial or ethnic group favoring people with lighter skin over those with darker skin.
In character design, colorism is expressed through association of dark skin tones with evil and lighter skin tones with good.

Cultural Identifier:
Visual information that that indicates a derivative of or a relation to a particular culture.

Cultural Production:
The social processes involved in the generation and circulation of cultural forms, practices, values, and shared understandings.

Culture:
the customary beliefs, social forms, and material traits of a racial, religious, or social group.

Expertise:
the skill of an expert.
Visual cues that imply a mastery over a trade, skill, or ability.

Feminine:
characteristic of or appropriate or unique to women.
A visual byproduct of gender norms.

Gender:
the behavioral, cultural, or psychological traits typically associated with one sex.
Visual information that relates to the gender of character design.

Gender Presentation:
Refers to the external appearance, dress, mannerism and behavior through which each individual presents their gender identity, or the gender they want to appear as.
For design purposes, the visual cues used to imply a character's gender or lack thereof, define its gender presentation.

Intersex:
Intersex is a general term used for a variety of conditions in which a person is born with a reproductive or sexual anatomy that doesn't seem to fit the typical definitions of female or male.

Locality:
a particular place, situation, or location.
Visual cues that indicate, climate, terrain, diet, etc.

Masculine:
characteristic of or appropriate or unique to women.
(see feminine.)

Non-binary:
relating to or being a person who identifies with or expresses a gender identity that is neither entirely male nor entirely female

Phenotype:
the observable properties of an organism that are produced by the interaction of the genotype and the environment
Regarding character design, phenotype is the physical characteristics that indicate ancestry belonging to a race or people.

Posture:
the position or bearing of the body whether characteristic or assumed for a special purpose; the pose of a model or artistic figure

Race:
a category of humankind that shares certain distinctive physical traits
(Not to be confused with culture)

Racial ambiguity:
A character design capable of being interpreted as belonging to two or more racial groups.

Rule of 3/5ths:
A guideline for establishing the race of a character design.

Sexuality:
expression of sexual receptivity or interest especially when excessive
A subset of gender norms that can be tied to a character's gender presentation.

Shape Language:
A visual communication technique used to convey emotion and mood through shapes and negative space.

Spirituality:
sensitivity or attachment to religious values
Visual cues that imply a connection to or an affinity for religion, piety or unconventional belief systems.

Theme:
a subject or topic of discourse or of artistic representation; a specific and distinctive quality, characteristic, or concern
Aesthetic choices that tie a design together with a philosophy or ideological perspective.

Value:
relative worth, utility, or importance

APPENDIX III: FURTHER READING

There is a wealth of knowledge outside these pages, here are some that I fully recommend.

1. Pantome guide to communicating with color by **Latrice Eiseman.**
2. Vanishing point by **Jason Cheeseman–Meyer**
3. Understanding the invisible art of Comics by **Scott McCloud**
4. Expressive Anatomy for comics and narrative by **Will Eisner**
5. Graphic Storytelling and Visual Narrative by **Will Eisner**
6. How to draw Noir Comics by **Shawn Martinbrough**
7. Framed Ink by **Marcos Mateu–Mestre**
8. Pop Painting: Inspiration and Techniques from the Pop Surrealism Art Phenomenon by **Camilla d'Errico**
9. The Complete Color Harmony, Pantone Edition by **Latrince Eiseman**
10. Reproduction of white privilege in visual art education by **Roberta S. Bennett**
11. Black Representation in American short films (1928–54) **by Christopher P, Lehman**
12. Incidents in the life of a slave girl by **Harriet Jacobs**
13. The New Jim Crow by **Michelle Alexander**
14. White Fragility **by Robin Di-angelo**
15. Stamped from the beginning: The definitive history or racist idea in America by **Ibram X. Kendi**
16. Between the world and me by **Ta–Nehisi Coates**
17. Invisible Man by **Ralph Ellison**
18. Everyday Use by **Alice Walker**

How to Draw Black People

ACKNOWLEDGEMENTS

This book was made possible by 588 patient people who believed in me and waited for my slow ass to finish it.

Seriously, thank you.

You changed my life.

Lindsey Bailey
Unlikely Heroes Studios
Tasha Turner
Cassandra Washington
Hyla Lacefield
Adriane Ruzak
OfficerM
DeMarco Ryans
Domonique Lowe
Guest 173942778
Perry Clark
Lola Ibitoye
Kerrena Fortune
Phillip Buck
Orion Ovaettr
Guest 2071705599
Guest 1758167688
Rezllen
trojanzer
Love
paul naas
Zakh Fair
Gio Marko
Pharoah Bolding
Kevin Clark

Erica Lindsey Ross
Brad
Kevin Leverett
Emily Levin
C. Christopher Hart
Guest 1510912086
Joseph Lechuga
Suzie Duncan
Sunshine Lewis
The Starlight City Project
Guest 1734949945
Guest 1531684788
Whitney Cook
Marcus
Anthony Lewis
Guest 1232891102
Lucia Irene Soltis
Matt Baker
Jamie Jeans
The Underwoods
Ralph Riggiladez
Jake Baerkircher
Blair A Mason
Annalise
Chris & Maggie
Benjamin Boston
Shannon Ortberg
Christen Williams
Gearald William Becker
Rahadyan Sastrowardoyo
Calvin Contreras

Guest 1131950958
Aamaal Abdul-Malik
Jason Harrison
Optimistic Michelle
R~
Dakota Cruz

Matthew Goins

Ed

Najah Dunham

Kas Roth

Dimitris Moore

Thomas Gladhill

Alyea A. Chandler

Lex R

Scott Rhatigan

Nefertiti Ivy

Kerstin A. La Cross

Charles Mayo

Jonathan Martin AKA Jonny X

Jenee Hughes

Guest 1175280869

Randy Reeves

Christopher Sulat

Danny

Zakia

Helena Isis

Quintus Havis

Monica Sturdivant

Guest 36659404

TerriPease

Gary Simmons

Donna M. Jackson

Ellis Kim

Jennell Jaquays

"Filkertom" Tom Smith

tang0094

Monica Marlowe

J Manko

Shreyas

Ashley Nicole

Jamal Herc Stokes

Emily Rosato

Araina Britton

Shean Mohammed

Lior Cohen

Michael

Carl Slimp

Kate Flash

Ed McKeogh

Julio Santose Escabar

Paul Provence

Danny J Quick

Tashi

Robert Melquidaes Moreno

Sean Jenkins

Peter

Amy Carpenter Leugs

Gabrielle Hoyte

Renard McDaniel

Melissa Massey

Brandon Lindsay

Jazmin LaShae

Roscoe Glinton aka Johnny

Tsunami

Ken Leinaar

Guest 1579815935

Joe Smith

Kuma Tarantino

Pamela Davis

Kevin Wheeler

Jason Nolen

Philip Weiss

Chris Bishop

Nafeesa Davis

Chris Mitchell

Domenic Allen

Micha

Amanda Hamilton

Chiquita Oliver

Amber Jones
Amiynah Hanna
Dee Jai
Quinten McCollum
Creighton Leigh
Elise Bacon
Guest 1230133095
Adrienne Schatz
Sebastian A. Jones
Holly Heisey
AdiStroyer
Guest 469335783
Dan Morgan
Ken Mora
Becca Chiappone
Amanda Hathaway
D R Amani Bolden
Anna Terry
Starr of vipi.ink
Nickol Ortiz
Guest 1820290855
Arthur Newman
Celia Tesseur
Ashley S. Benson
Qustom
Guest 1861774078
CF
Patrick Rogers
Kenneth Bell
Eric M. Cooper
Nathaniel
Tauhid Bondia
Ed Watson
Guest 1421152437
Alisa Starr
Julie Levy
Brian Hawkins

Flare Star
Daizzy App
Greene County Cre
Courtland Ellis
Mike Haffenden
Chrisón Thompson
Elizabeth Edwards
Danny DeCillis
Chris Heidorn
Guest 494957936
Anthony C. Harris
Derek W. Lipscomb
Joy Lamont-Smith
Gene Kelly
Guest 1906786577
Frau Perchta
Guest 2075367886
James
jeffrey rousseau
Kathryn Hemmann
Justin Silva
Daniel Mardy
Mintlunarwing
zombietruck
Rick Goodvin
Khadija Harris
Amy Eastment
Jimmy Ogata
Rannva Macdonald
Andy "Shaggy" Kor
Renaissance
Yu Li Choe
Aaron Umetani
Tracie Yorke
Mandie Bentz
Paul Benincasa
Brandon J. Rodak

How to Draw Black People

Larissa Lee
Unique
Matt Walters
derrek wilson
Napturalista Moji
brokedownsystem
Molly Lohman
Kenneth V Heard
A.J. Kinkade
Orlando Baez
Gordon Motsinger
Haley Millman
Guest 1749134793
deVidiax
Burke Morton
America Young
Emma Lysyk
Darrel Troxel
Bartholemew Powers
June Howard
Paige Alfred
Catherine Pennington
Guest 1709675090
Guest 2039330522
Matthew
Brian Rodman
Jacques E Nyemb
Garrett Nicholas Cole
Samantha Netzley
Guest 581955729
Beverly Bambury
Ben Arnon
Molly Silverstein
Jermaine Charles
Tab Kimpton
Reiko Ara Meyers
Christopher Wade

Phillip Marrae Vaughan
James C Washington
John Wigger
Sascha Wiebenson
Heather Burns Bethel
Eric Bradaigh
Guest 834100648
Lamont Wayne
Rizzopat
Arthur Johnson IV
Domonique Williams
Jennifer Wu
Todd Michaels
Kat Greene
Weston Teruya
Lost Colonies Larp
Marie Stanley
Antonio Campos Jr from
McAllen Texas
Guest 331475848
Lök Zine
Guest 2017091875
Luis Alberto Correa
Philip Edward King
S R
Jeremiah Parry-Hill
Jourdan McLain
Tremaine Worrell
Annie Erskine
Marinda Cassidy
Behonkiss
Guest 2140058528
B.B.
Guest 688982921
Christopher Brown
Kofi Jamal Simmons
Elizabeth

Lynn Brown
Ashley Tyler
Qiana Whitted
Grant Thomas
Chloe Spencer
Melissa M.
Julia Cook
Yusuf Morgan
Kedra
Guest 1632911796
Guest 2023230562
Trevor Von Klueg
Sean K Reynolds
Sylverthorne
Guest 1206024406
belenen
Gabrielle Shea
Tanya S
Daniel Ronnell Reaves
Talia
Jessika Hutchinson
Zoa
Guest 1089297919
Ronald Usethesecond
Adrienne
Amberle Husbands
Shanna Germain
Shareya
Robert
Joe D McFee
Michael Lingefelt
Guest 380663140
Peta-Ann Smith
Guest 123498959
Trey Washington
P C
JJ Jacobson

Margarette Shegog
Tanisha Woodson-Shelby
Thomas Gore
Carrie McLaughlin
Chris Crossman
Guest 1117876731
Palwasha Azimi
Ron Cole
Guest 228353740
David Chaucer La Forest
Guest 1583554772
Faith Cheltenham
Naomi Parrish
RF
Azathoth McGee
Colleen Winters
Farah Rizal
Gerry Chow
Alex Molnar
Sara Harvey
Gestaltar skiten
Richo Wade
Kelly Lightle
Guest 406755666
Russell Akred
John Sauter
Jason Watler
margot
Capone Comics
Guest 1000384928
David Bolack
Logan Shannahan
Christopher Newell
Mark James Featherston
Amanda
Michelle Carnes
Guest 1209480195

How to Draw Black People

Jeff Brady
Naomi Curland
LA
Kiarra A. Yarbrough
Barrington Edwards
Devon Tull
Nikoline
Ariane Broome-Hopkins
Stephen Lea Sheppard
George Romaka
dragonaire
David Balan
Matthew Darlison
Suwada Hinds
Allison
Gary Francis
Jamie Garrard
Cheryl Kennedy
Layla A. Reaves
Jed Hartman
Clifford Johnson
Bob Covey
Peter Green
Nicholas Eng
Keenan Belmont
Bear Weiter
YOSMAN RUCKER
Sheila Addison
KR Hinton
Guest 259391941
Dre McHenry
Sushu
Jordan Miller

Ofeibea Loveless
Forest Kistner
Philip H Hughes
Kendall Howse
Yoon Ha Lee
Maurice Cherry
sergio alcantar
Guest 1303850638
Julie Heidt
Laurel McAllister
Sarah Schaefer
Guest 726570318
Sarah Adkins
Cairis Ross
LaToya Burt
Ras Mitmug
Joane B
Lena Horsley
TL Cox
Stephen Walrond
Mark Alexander Martínez
Lauren Sugrue
Dalles Johdiamondkiss-
myass Cheatham
Kathleen Duggan
Morgan Tupper
Fernando Ruiz
Willie Winters
Nick Ulanowski
Kevin Saari
The Museum of Advertising
Tania Walker
Phil Morrissey

SDarkshine

Karson Cogswell

Jennifer

Karat McFall

Xopher Seuss

RiffingTheVerse

Terry O'Carroll

Ethan Jennings

Tara "fend" Hamilton

DD

Samantha Dahlstrom

Kristin DeBoom

Veronica Drapeau Miller

Joshua Borlase

Angel

Jen Huber

Christopher

Robert Pope

Joseph C Shade

Maggie

Bethany Barnett

Jon Jebus!

Jordan

izsch2

Andi Dukleth

Tomas Aleksander Tangen

Saga Mackenzie

Matt K

David Voegtle

Carlos Martinez

Arinn Dembo

Ludovic Mercier

Andrea Kahn

Jamie Jackson

Stephen

Leah M.Art

Michael Benoist

Wendy Sheridan

Debrie Woods

Abraham Melendez Jr.

Jules Purnell

Brian Hum

Marc

Steve Brennen

Demon

Fyl Frazee of Rogue Bard
Media LLC

Chris Broome

M. R. Turnage

Guest 34318313

Simon Kingaby

Clark Snyder

DryFrogPills

Lily H.

Ingrid Law

Adrian Gordon

JM

Burning Spear Comix

Chris McGrath

Tim Jordan

Justin Rachels

satomi kuramochi

Jocelin Ladybug Leige

Rhel

Kamina Kapow

Troy Cole

Wes Kocher

Onawa NS

Mystic Raven

Jesalyn Blount

Guest 1107237360

Jay Hosler

Kashawn Henry

Brian Dysart

James
Dwayne
Guest 1908242060
Kyle C Coleman
Sean Barrett
Jennie Mallory
Lee Brown
Richard Hernandez
Todd Thomas
Joe Nelis
Meta Anna Campbell
Daniel Licht
Naoise McHugh
Chanin Vichaita
Chad
Kathleen
Ken Elliott
Ky Brabson
Jamal Narcisse
Kyle A Banks
Tuesday Una Villa
Leora Effinger-Weintraub
Kyle Rose
Colin Fredericks
Daniel Curtis
Sharyna
RC Young
Guest 675512291
Roxanne Ready
Tobi Hill-Meyer
Paula
Virginia Cartwright
Gabriel Cantu
Dave McFalls
Rachel Fisher
Michelle Pendergrass
Allysha

Ivorycrow
Isis Bass
DarkWhite
chomiji
Shawn Pryor
Haevermaet Anthony
Meghann Pardee
Rachelle Meyer
Excited Designer
Sewicked
Fenecia Jones
M
Krist Tondro
Misha B
Stephen Thomas
emacgregor
Ross Demma

How to Draw Black People

THE ART OF MALIK
SHABAZZ

THE ART OF MALIK
SHABAZZ

THE ART OF MALIK
SHABAZZ

THE ART OF MALIK
SHABAZZ

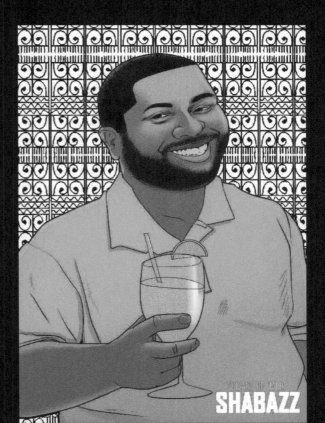

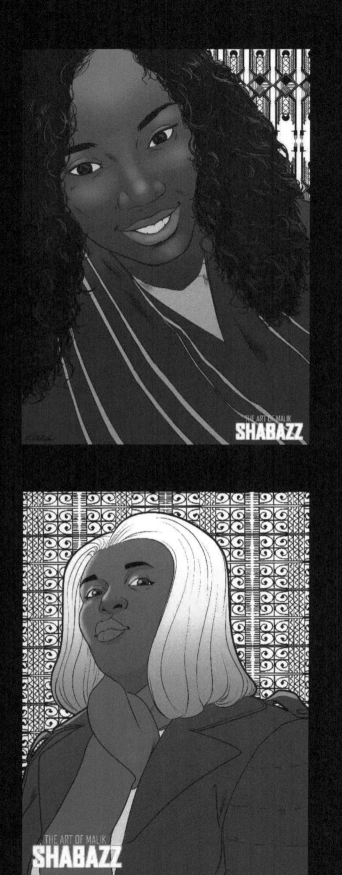

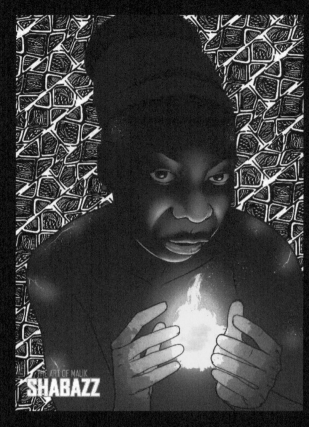

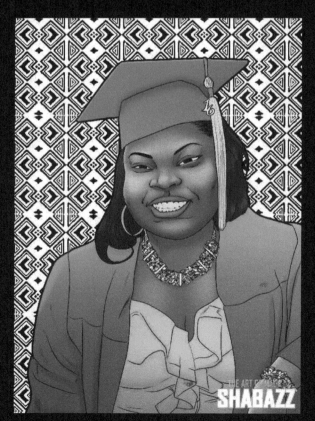

How to Draw Black People

Thank you so much for reading this book.

Sign up to my newsletter at www.Malik-Shabazz.com for updates about this book, future signings, or conventions. You can follow me on Instagram and twitter @Shabazzarts

If you have a question about this book feel free to contact me at ShabazzMalikali@gmail.com

Never Lose Your Way

CPSIA information can be obtained
at www.ICGtesting.com
Printed in the USA
LVHW072023291219
642016LV00006B/34/P